The Samuel H. Kress Collection
at the Seattle Art Museum

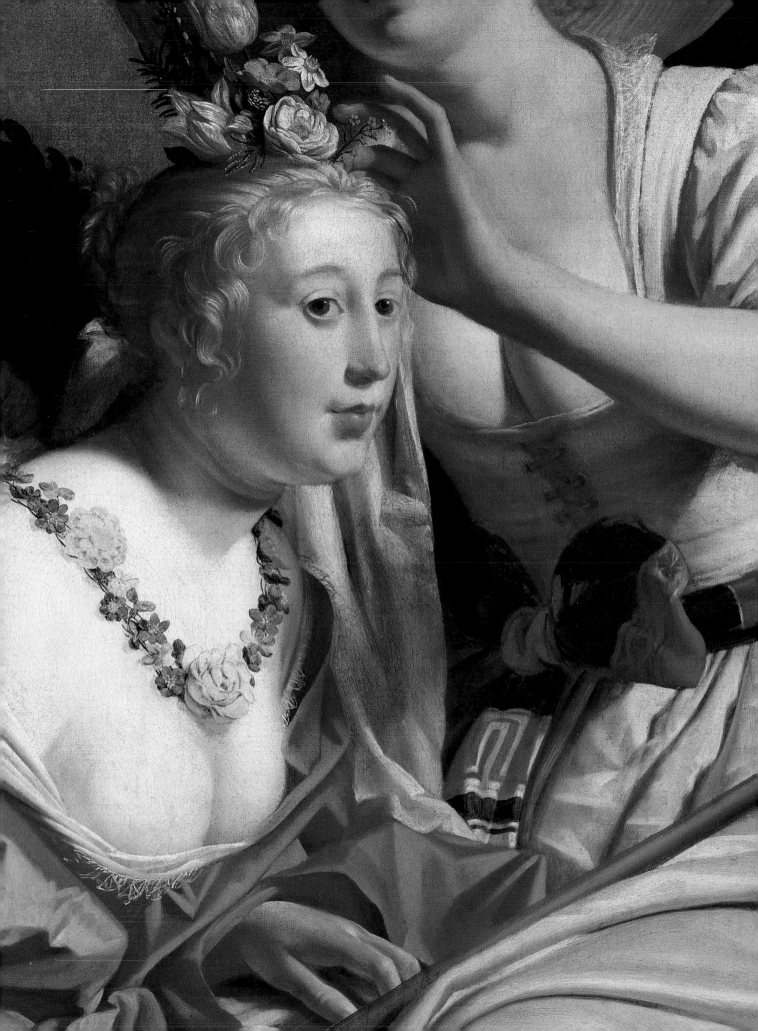

The Samuel H. Kress Collection at the Seattle Art Museum

CHIYO ISHIKAWA

Seattle Art Museum

Published by the Seattle Art Museum
Seattle, Washington

Edited by Lorna Price
Designed by Ed Marquand
Produced by Marquand Books, Inc., Seattle
Photography by Eduardo Calderón, pp. 17, 19, 27, 28, 35, 36, 38, 40, 43, 44, 47, 62, 67, 73; H. C. Davidson, p. 10; Susan Dirk, pp. 24, 34, 61; Earl Fields, pp. 26, 74; Paul Macapia, front cover, pp. 2, 6, 12, 15, 18, 20, 21, 29, 30, 33, 37, 39, 42, 46, 48, 50, 54–56, 58, 60, 63, 65, 66, 68, 71, 72; Mario Perotti, p. 32; Paul V. Thomas, p. 8 (right).

Cover: Detail of fig. 17, Master of the Straus Madonna, *Adoration of the Magi*, c. 1390
Frontispiece: Detail of fig. 41, Gerrit van Honthorst, *Shepherdess Adorned with Flowers*, 1627
Page 6: Detail of fig. 45, Jacopo Robusti, called Tintoretto, *Gabriele di Pietro Emo, Procurator of San Marco*, 1572

All objects are from the Seattle Art Museum's Samuel H. Kress Collection unless otherwise indicated. For dimensions, height precedes width precedes depth.

Library of Congress Cataloging-in-Publication Data
Seattle Art Museum.
 The Samuel H. Kress Collection at the Seattle Art Museum / Chiyo Ishikawa.
 p. cm.
 Includes bibliographical references.
 ISBN 0-932216-47-1 (alk. paper)
 1. Painting, European—Catalogs. 2. Kress, Samuel H. (Samuel Henry), 1863–1955—Art collections—Catalogs. 3. Painting—Washington (State)—Seattle—Catalogs. 4. Seattle Art Museum—Catalogs. I. Ishikawa, Chiyo. II. Title.
ND450.S43 1997
759.94'074797'772—dc21 97-25152

Printed in Hong Kong

Contents

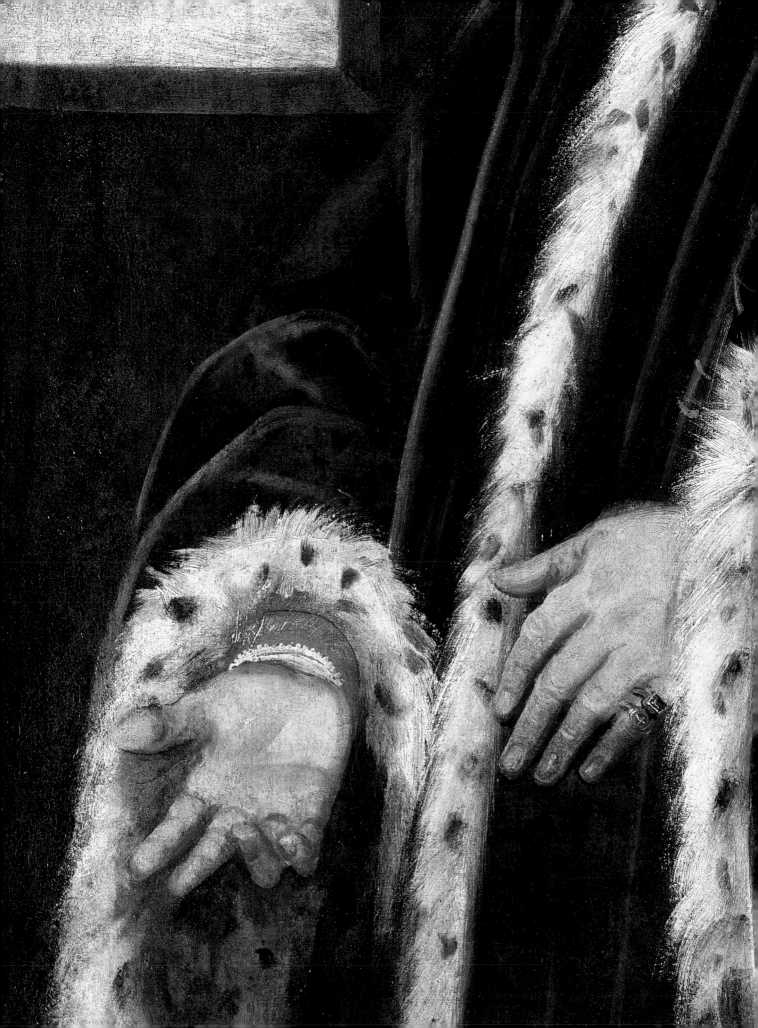

Foreword

Visitors to the Seattle Art Museum have been enjoying the Samuel H. Kress Collection of European paintings for twenty-five years. With the generous support of the Kress Foundation, we are now able to present a long-overdue publication, the first since 1954, on this fine collection. It is no exaggeration to say that without the Kress Foundation there probably would not be a collection of European painting at the Seattle Art Museum. The Foundation organized a seminal traveling show that came to Seattle during the depression, chose Seattle to be a Kress regional collection, and helped fund the first curatorship of European art in 1990. Our Curator of European Painting, Chiyo Ishikawa, has written the following essays to introduce a new generation of visitors to the Kress Collection by tracing the history of the collection here and discussing the paintings in the context of their original purpose. I would like to express admiration and heartfelt gratitude to Chiyo for her lucid text and intelligent oversight of Seattle's Kress Collection.

This publication was made possible by the generous support of the Samuel H. Kress Foundation, whose continuing interest is greatly appreciated. For their assistance and advice throughout preparation of this manuscript, we are especially grateful to Marilyn Perry, President, and Lisa Ackerman, Chief Administrative Officer, as well as Gail Bartley, Dianne Dwyer-Modestini, and Jenny Sherman. Thanks also go to Albert Wagner of the Kress archives at the National Gallery of Art. At the Seattle Art Museum, interns Gretchen Herrig and Mark Mitchell contributed to research on our paintings while Dorothy C. Malone, who was a staff member and supporter of the Seattle Art Museum from its inception until her death in 1997, was an invaluable source of information about the early years of the institution.

MIMI GARDNER GATES
The Illsley Ball Nordstrom Director

Fig. 1. Samuel H. Kress in the
early 1900s.

Fig. 2. Richard E. Fuller,
founder and first director
of the Seattle Art Museum,
in 1964.

The Collection of European Paintings at the Seattle Art Museum

The European collections of the Seattle Art Museum owe much to Samuel H. Kress (fig. 1), American philanthropist, patron of the arts, and a legendary American grassroots success story. Kress and Richard E. Fuller (fig. 2), the Seattle Art Museum's founder, first director, and principal donor, shared a love for art and the conviction that it offered affirmation of the best qualities of the human spirit—though the two had little else in common. Kress was a self-made man; Fuller came from privilege and commanded the resources to follow his vision of a collection undeterred by circumstance or qualification. At the time the two men first became aware of each other, Richard Fuller was engaged in building a great Asian collection for the Seattle Art Museum. Fuller (1897–1976) was a doctor's son, who had made the requisite trips to Europe and Egypt suitable for young men of his social standing and income. But he and his mother were far more taken with Asia, where the entire family traveled together in 1919–20, and where their own art collecting originated.[1] Having earned a Ph.D. in geology from the University of Washington, Fuller was especially drawn to jades and other stones carved into decorative objects or snuff bottles.

Two years after the stock market crash of 1929 and one year after his father's death, Fuller and his mother agreed to donate their diminished inheritance, $250,000, to construct an art museum in Seattle's Volunteer Park. It would be a formal home for the Seattle Fine Arts Society, which had existed since 1905. From the outset, Fuller had broad ambitions for the museum, but his personal enthusiasm as a collector ran toward three-dimensional objects—"things you could hold in your hand" in the words of a colleague, rather than paintings. His collecting energies were directed toward the acquisition of objects such as Chinese jades, Qing dynasty funerary figures, and contemporary Northwest art (the start of Seattle's important collection of regional painters including Tobey, Graves, and Callahan), but Dr. Fuller initially chose to represent European art by photographic reproductions.

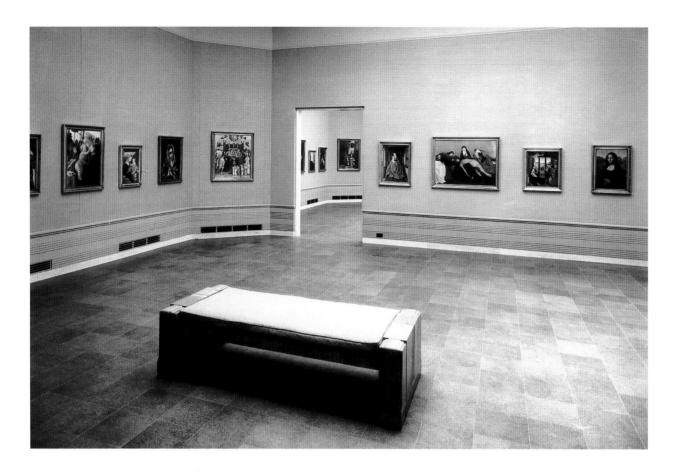

He hung framed color facsimiles of famous masterpieces. This allowed the museum to mount exhibitions in which Leonardo's *Mona Lisa* hung next to Rogier van der Weyden's *Saint Luke Drawing the Virgin* (fig. 3)—an arrangement impossible in actuality, since the two originals reside in museums in different cities. Sometimes when the museum hosted traveling exhibitions, facsimiles were exhibited beside original paintings.

In hindsight, it is easy to dismiss such an approach: museum professionals generally believe that important qualities inherent in the original work of art cannot be communicated through reproductions. But Dr. Fuller's action was not unusual at the time. Plaster casts of classical sculptures and architectural monuments had long been the pride of many important museums and teaching institutions, illustrating the belief that it was better to show faithful reproductions of art of the highest quality than to show lesser art in the original. By the early twentieth century, tastes had changed. The medium of sculpture, so prized by the Victorians, had been superseded by painting, which now could be reproduced photographically. Like most people in the 1930s, Fuller had great faith in the veracity of photographic reproduction—a concept that has since become highly qualified.[2]

Fig. 3. Framed color facsimiles of famous paintings representing European art in exhibitions at the Seattle Art Museum in the 1930s.

The first important event involving European art in Seattle was the arrival, in 1933, of an exhibition of fifty-six Italian paintings from the collection of Samuel H. Kress (1863–1955). Born in Pennsylvania, Kress managed to save enough money from his monthly schoolteacher's earnings of $25 to open a small notions shop in 1887. It was the seed of what became a national empire of five-and-dime stores; in ten years, they transformed Samuel Kress into one of the country's wealthiest men. After retiring from daily management of his business interests in the 1920s, Kress began to collect Italian paintings, an edifying hobby pursued by many other self-made American businessmen, including Henry Clay Frick and J. P. Morgan. Kress's collecting methods were distinguished by a wholesale approach: his aim was to own a representative work by every artist of every school of Italian art. From these naive and ambitious beginnings grew one of the greatest collections of Italian art in the country, eventually numbering almost 3,000 objects.[3]

Though it is hard to imagine Richard Fuller and Samuel Kress sitting down and conversing about experiences they had in common, the two men shared a similar response to the economic devastation of the Great Depression: a belief in the power of art to lift the human spirit, and the conviction that privileged individuals have a responsibility to contribute to society through philanthropy. Fuller's Seattle Art Museum opened in 1933, in the midst of the Great Depression. At exactly the same time, Kress organized a tour of over fifty Italian paintings from the fourteenth to the eighteenth centuries; it traveled by train throughout the country. He charged nothing to view the exhibition and booked stops in twenty-four cities with S. H. Kress stores. He used his astute marketing instincts to lift the spirits of a depressed populace while rewarding loyal customers.

In the fall of 1933, the brand-new Seattle Art Museum was not ready to host the Kress exhibition (which was shown instead at the University of Washington's Henry Art Gallery), but Kress was aware of Fuller's plans. Three years later, the Kress Foundation, established by Kress in 1929, announced the gift of an Italian Renaissance painting to the Seattle Art Museum, "where we understand you are endeavoring to gather together works of art of various kinds to make it a permanent institution." In an old-fashioned, formal style, the letter explained:

> The thought might arise in the minds of certain people why
> we are expressing our interest in Seattle in this manner and wish
> to say that it is apparent that opportunities to obtain genuinely old

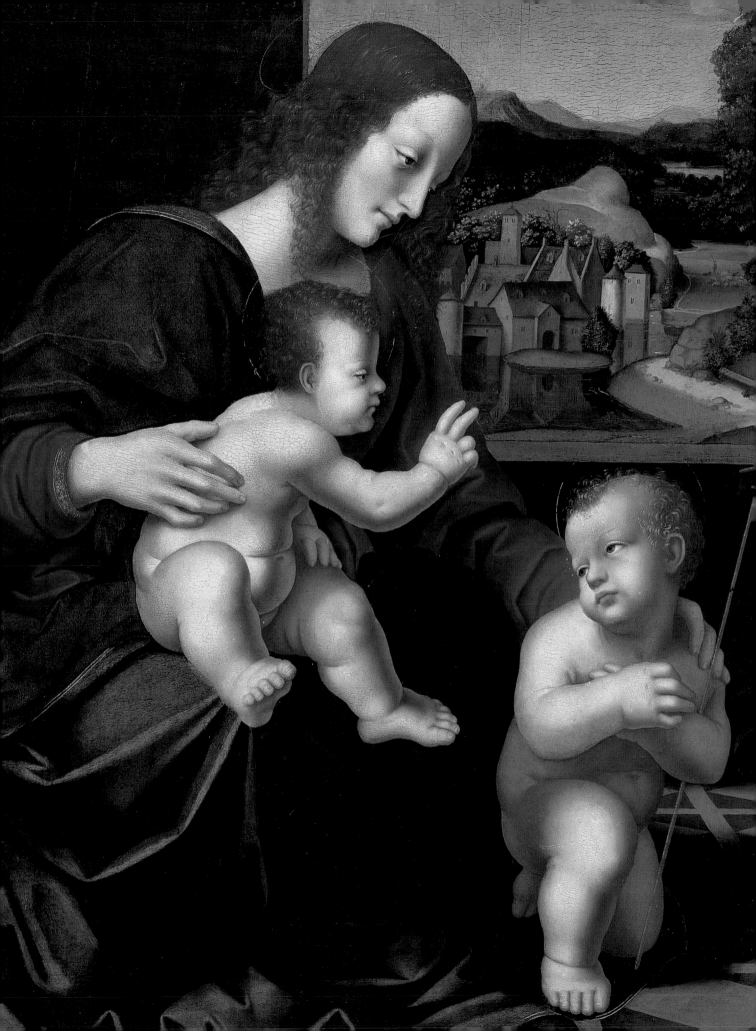

paintings of quality, within the range of those being acquired by
museums throughout the United States, are continually becoming
fewer, for naturally the number of genuinely old paintings is lim-
ited and because of the greater interest shown in matters of art in
many cities of our country particularly, as well as in other coun-
tries, those that once become a part of a museum are supposed to
be so settled that they will be out of the market for all time.[4]

In other words, the Kress Foundation wanted to help fledgling collections
in an age of dwindling financial resources and a shrinking art market. The
letter also clarified that this gesture was meant to build on an interest in art
already demonstrated by the establishment of the museum in Seattle.

The painting *Virgin and Child with Saint John the Baptist* (see fig. 25) was
attributed to Marco d'Oggiono, a Milanese artist from the circle of Leonardo
da Vinci. Richard Fuller wrote gratefully to Samuel Kress: "As the initial Eu-
ropean old master in the collection of the Museum, it establishes a standard
which I trust [we] will always be able to maintain."[5] The next year the Foun-
dation presented another gift to the museum, a portrait of a young man at-
tributed to Jacopo Robusti, known as Tintoretto.[6] In the next ten years, the
Seattle Art Museum also acquired fifteen paintings on its own, seven of them
purchases, as well as a number of works of European sculpture. Kress's desire
to enliven interest in European art in provincial centers through key dona-
tions was thus modestly fulfilled in Seattle.

From 1938 to 1946, Samuel Kress and the Kress Foundation were closely
involved in the new National Gallery of Art in Washington, D.C. Over four
hundred paintings and thirty-five works of Italian sculpture from Kress were
placed on view for its opening in 1941. On behalf of the National Gallery,
the Kress Foundation was the most active American buyer of European art
throughout the years of World War II, taking advantage of a depressed mar-
ket and the sudden wartime availability of major works of art. By 1947 the
collection had grown to over six hundred works of art, two hundred of which
were now placed in storage.

After Samuel Kress's health declined irreversibly in 1946, his younger
brother Rush took over the operations of the Kress Foundation and initiated
a project that would have lasting significance for museums across the country.
The Regional Galleries program emerged from the Kress Foundation's wish
to have the entire collection on view, including the works presently in storage
at the National Gallery. Rush Kress believed that the collection would be of
greater benefit to the public if paintings were distributed to museums around

the country. This truly original program of art philanthropy was a natural outgrowth of Samuel Kress's traveling exhibition during the depression and his gifts of art to individual museums. Once again, gifts would be tied to areas where Kress stores thrived. The Kress Foundation promised the works of art themselves, conservation, shipping, insurance, photographs, x-radiographs, and scholarly documentation. In exchange, the receiving institution would agree to permanently display the collection and guarantee security, appropriate light levels, and control of temperature and humidity.

In 1950 the young assistant director of the Seattle Art Museum, Sherman Lee, initiated contact with the Kress Foundation despite Dr. Fuller's hesitation to permanently commit a gallery of his small museum in Volunteer Park to an unchanging installation. Lee had been hired by Fuller for his expertise in the art of Asia, but he also raised the standards for European art at the museum. During his four years in Seattle (1948–52), he retired the facsimiles of paintings and curated significant exhibitions such as "Masterpieces from the Metropolitan Museum of Art" (1952) and "Caravaggio and the Tenebrosi" (1954).

The Kress Foundation agreed to make the Seattle Art Museum one of eighteen regional museums, which meant that it was in competition not only with the other seventeen, but also with the National Gallery, which got first choice of objects. In a letter to the Kress Foundation in 1950, Lee showed the mettle that would help him later become a distinguished museum director. He took the bold step of asking the Kress Foundation to improve the quality of the paintings selected for Seattle so that they would meet the level of the rest of the museum's collections: "While the National Gallery is the great painting gallery for this country, we in the other regions feel our responsibility keenly and we cannot honestly accept a tertiary position in the European field when our other collections match, and in some cases surpass, such national collections in Washington as the Freer."[7]

The Kress Foundation responded by adjusting the original list. Twenty-three paintings from the fourteenth through the eighteenth centuries and two works of sculpture were finally settled on. They included the forceful *Flagellation* by the fourteenth-century Bolognese painter Dalmasio (see fig. 18), a haunting *Hagar and the Angel* by Bernardo Strozzi (see fig. 31), and a damaged but extraordinary ceiling painting designed by Giovanni Battista Tiepolo, along with his sketch for it (see figs. 38 and 37). Some of the paintings were from the Kress Collection; others, such as the Tiepolo ceiling, were bought specifically for Seattle.

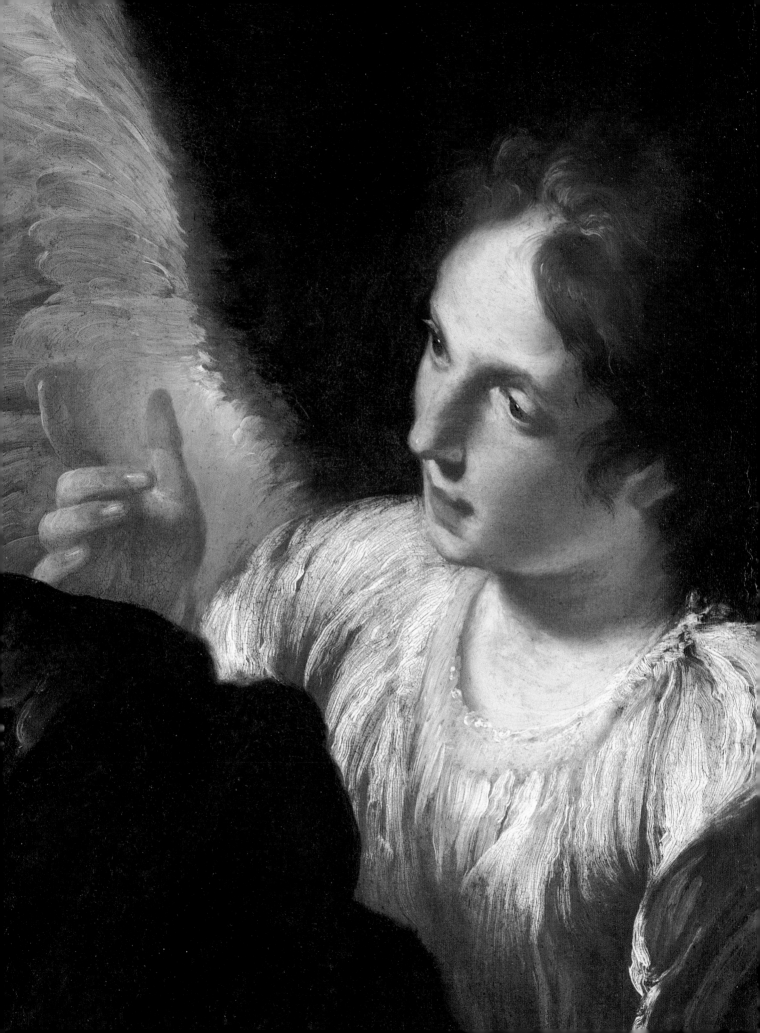

For the June 1952 opening of the Kress Collection installation in Seattle, Lee hung the works of art in a single museum gallery with dark blue walls. Rush Kress attended the opening and was unhappy with the tight arrangement of paintings stacked one above the other in the small gallery; his comments were reported in the local newspapers. In a letter to a Seattle friend, Rush Kress complained:"The hanging arrangement looks like an accumulation of three or four months' work on top of your desk."[8] The Foundation threatened to withdraw the paintings from Seattle unless more space was found for the collection by 1955.

By then Lee had already moved on to the Cleveland Museum of Art, but in Seattle the strong interest in European art was kept alive by Norman Davis, a museum board member who provided the anonymous donation that permitted the addition of a new gallery in the museum. As a reward for turning around a disastrous situation, the Kress Foundation offered an additional gift of paintings. Davis suggested in a letter to Richard Fuller that the museum request non-Italian works this time. He wrote:"It may be that the Kress people will confine us to Italian paintings only, but I understand from you that they are not quite so rigid. If we can get some Dutch, Flemish and French, as well as Italian paintings, we could have a wonderfully fresh and vivid gallery from a field where quality is more freely available and at far less cost."[9]

This modest request had as much impact on the shape of the Seattle Art Museum collection as Sherman Lee's daring letter to the Foundation three years earlier. The move into northern baroque painting was timely, both because of the availability of first-rate works on the market, and because there was little competition among other Kress regional museums. Besides the National Gallery, only the Allentown Art Museum in Pennsylvania had any number of Dutch and Flemish paintings. The paintings from the second donation are among the strongest in Seattle's collection and include some of the finest Kress paintings anywhere: a brilliant Rubens oil sketch of *The Last Supper*, a sunny pastoral scene by Gerrit van Honthorst, and a glittering *Banquet Still Life* by Abraham van Beyeren (see figs. 22, 41, and 43).

The final list was still being negotiated two months before the next opening, of the *two* Kress galleries in October 1954. This occasion was far more auspicious than the first, and even Rush Kress pronounced himself pleased. The collection, now numbering thirty-three paintings and two works of sculpture, was formally given to the Seattle Art Museum on December 9, 1961, at a ceremony at the National Gallery of Art, which President John F. Kennedy attended.

Detail of fig. 43, Abraham van Beyeren, *Banquet Still Life,* c. 1653–55

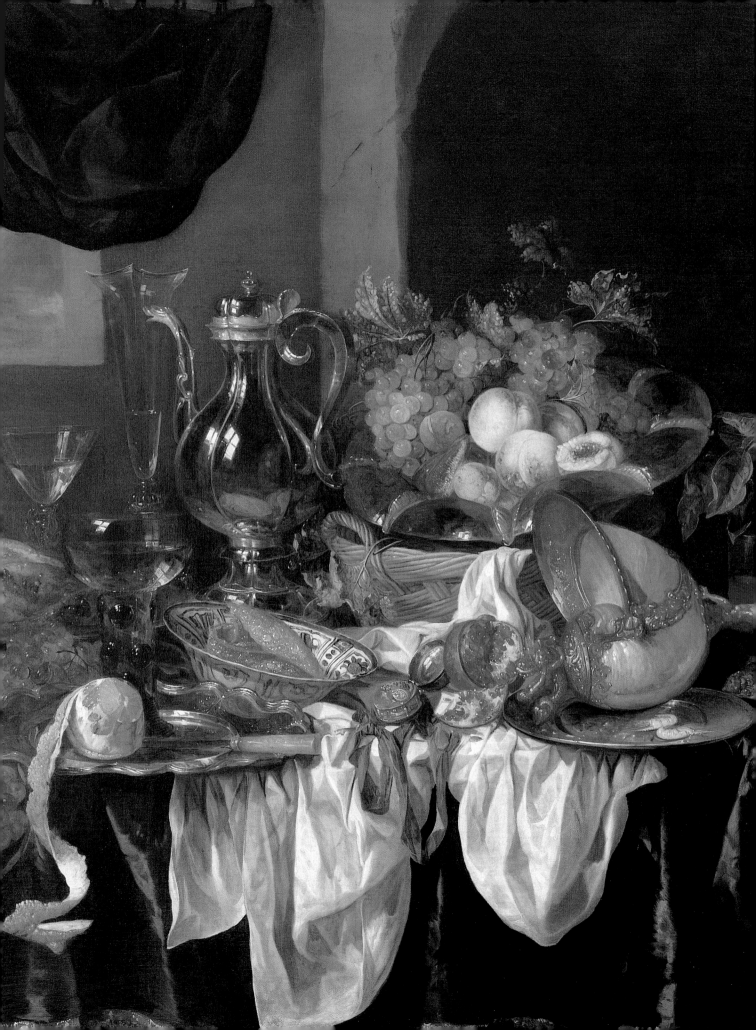

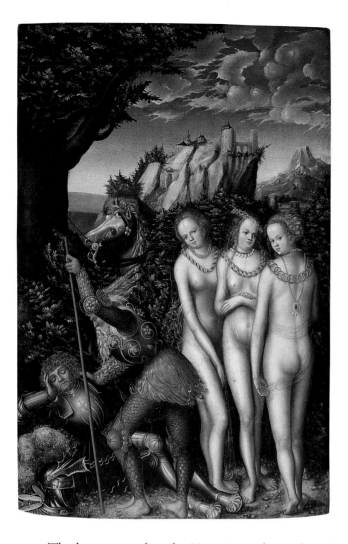

The leveraging that the Kress Foundation hoped to encourage with the gift of these works of art was indeed one result of its generosity. In the 1950s Seattle's European painting collection grew by twenty-eight more paintings—a respectable number, considering that other areas of the collection also continued to expand. A *Judgment of Paris* by Lucas Cranach (fig. 4), the first German painting in Seattle, was given by local collector LeRoy Backus in 1952. Two years later the museum bought Luca Giordano's boisterous *Triumph of Neptune* (fig. 5). Thirty-one old master paintings were added to the collection between the Kress donation in 1961 and Richard Fuller's retirement in 1973, including a magnificent painting by Abraham Janssens representing *The Origin of the Cornucopia* (fig. 6), purchased on the occasion of Fuller's seventy-fifth birthday in 1972.

A succession of directors guided the museum in new directions, building up holdings in contemporary and African art. No further additions were made to the European painting collection until 1987, when a new director,

Fig. 4. Lucas Cranach the Elder (German, 1472–1553), *Judgment of Paris,* c. 1516–18. Oil on wood, 25 x 16½ in. LeRoy M. Backus Collection, 52.38

Fig. 5. Luca Giordano (Italian, 1632–1705), *The Triumph of Neptune,* c. 1692–1702. Oil on canvas, 78 x 101 in. Eugene Fuller Memorial Collection, 54.161

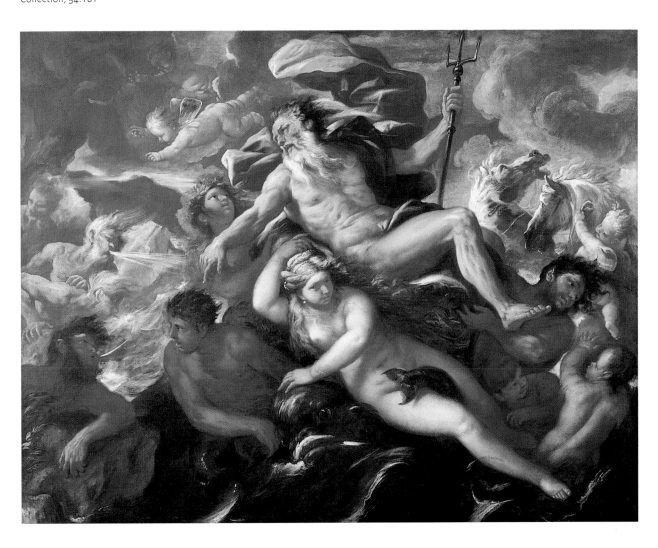

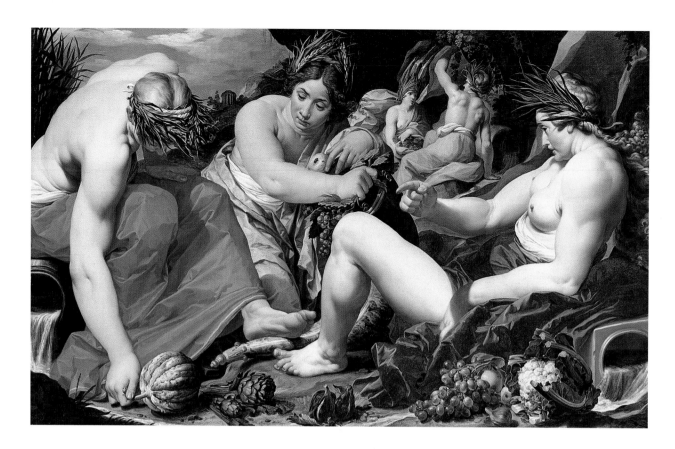

Jay Gates, purchased a delightfully intimate French portrait of a woman by Jacques-André Joseph Aved (fig. 7). In recent years, a fine Spanish painting by Antonio Palomino was bought for the collection, representing that country for the first time (fig. 8). The Kress Foundation's original restrictions of permanent and separate display were relaxed in 1961, and recent acquisitions could now be hung with Kress paintings. In the new downtown Seattle Art Museum, opened in 1991, Kress and non-Kress paintings hang together and are joined in the galleries by sculpture and decorative arts objects.

Unlike most other American museums, the Seattle Art Museum collections do not rest on a bedrock of European art. But it was fitting that when Seattle's benefactors looked to European art, they found the Kress Foundation, which since its inception has been synonymous with the best of the European tradition. In its international programs and ongoing support of the National Gallery and regional collections, the Kress Foundation continues to foster appreciation for a great heritage and works to keep this legacy viable for generations to come.

Fig. 6. Abraham Janssens (Flemish, 1575–1632), *The Origin of the Cornucopia,* c. 1619. Oil on canvas, 42⅜ x 67⅜ in. Purchased with funds from PONCHO in honor of Dr. Richard E. Fuller's 75th birthday, 72.32

Fig. 7. Jacques-André Joseph Aved (Flemish, act. France, 1702–1766), *Madame Brion, Seated, Taking Tea,* 1750. Oil on canvas, 50⅝ x 38¼ in. Purchased with funds from the Frederick Pipes Estate Fund, General Acquisitions, Mary Arrington Small Estate, and Eugene Fuller Memorial Collection, by exchange, 87.99

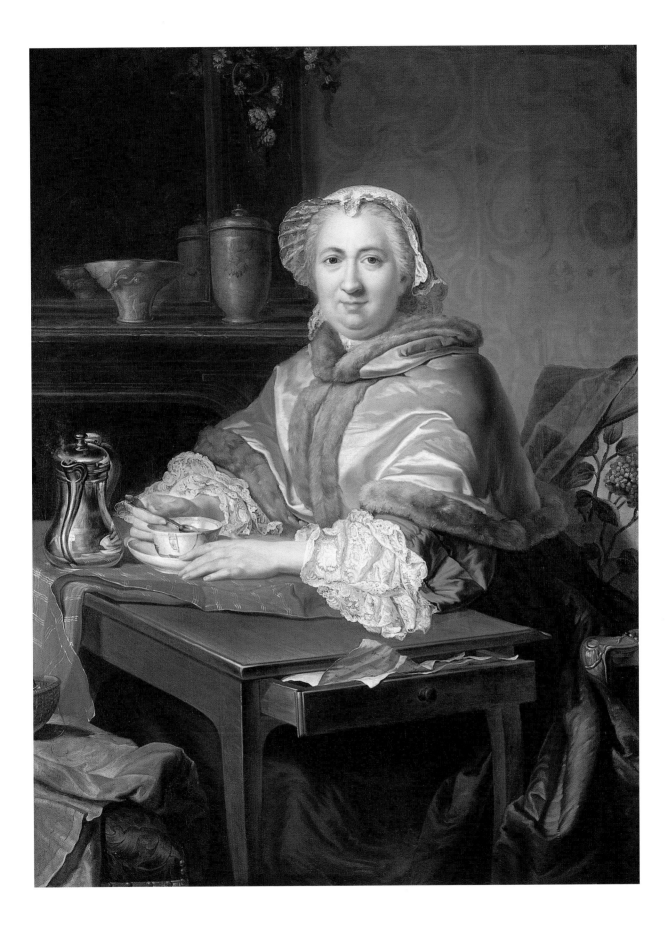

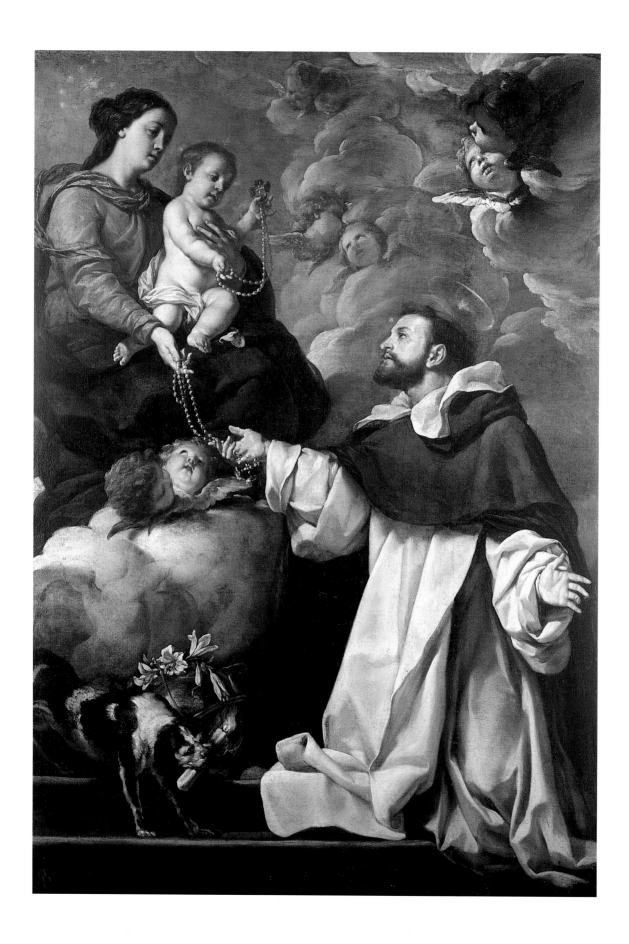

Fig. 8. Antonio Palomino
(Spanish, c. 1655–1726),
*The Virgin Presenting the Rosary
to Saint Dominic,* c. 1679–88.
Oil on canvas, 81⅛ x 57⅛ in.
Purchased with funds from the
European Painting Deaccession
Fund, Margaret E. Fuller Pur-
chase Fund, and Kreielsheimer
Foundation, 93.9

NOTES

1. For further information on Richard Fuller, see Richard E. Fuller, *A Gift to the City: A History of the Seattle Art Museum and the Fuller Family,* Seattle, 1993.

2. This entire discussion is surprisingly current again with the entry of another Seattleite, Bill Gates, into the realm of reproducing visual art. Gates's efforts to buy up rights to use images of works of art for projection, through digitization and high-resolution technology, onto the walls of his home is a technologically updated version of the "copy" philosophy and has stimulated another round in the debate of original versus reproduction.

3. See Marilyn Perry, "The Kress Collection," in *A Gift to America: Masterpieces of European Painting from the Samuel H. Kress Collection* (New York: Abrams, 1994), pp. 12–39.

4. Letter dated December 29, 1936, from the Samuel H. Kress Foundation to Seattle Art Museum; Seattle Art Museum files.

5. Letter dated January 13, 1937, from Richard Fuller to Samuel H. Kress; Seattle Art Museum files.

6. The painting was traded back to the Foundation in 1952. Now attributed to Domenico Tintoretto, it is presently in the study collection of Bucknell University at Lewisburg, Pennsylvania. It is reproduced in Fern Rusk Shapley, *Paintings from the Samuel H. Kress Collection: Italian Schools XVI–XVIII Century* (New York: Phaidon, 1973), fig. 114.

7. Letter dated May 22, 1950, from Sherman E. Lee to Guy Emerson of the Kress Foundation; Seattle Art Museum files.

8. Letter dated June 25, 1952, from Rush H. Kress to Joshua Green; Seattle Art Museum files.

9. Letter dated September 4, 1953, from Norman B. Davis to Richard Fuller; Seattle Art Museum files.

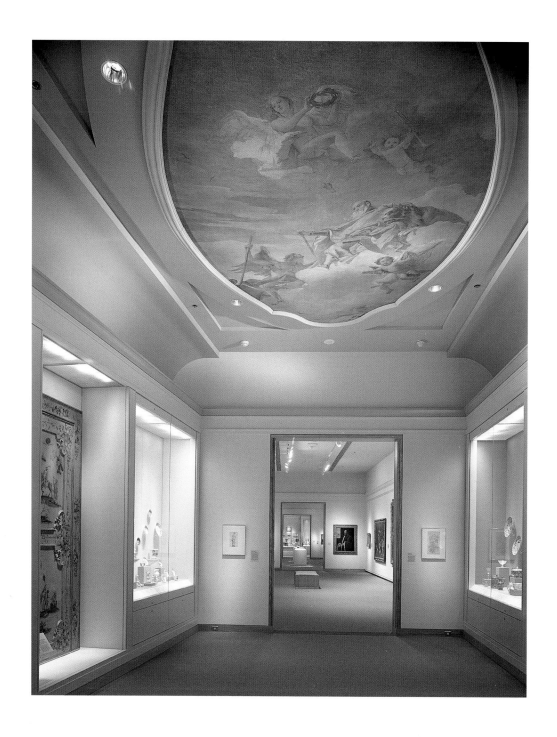

Fig. 9. European paintings and decorative arts are displayed together in the European galleries opened in 1991.

The Changing Functions of Works of Art: Looking at the Kress Collection

INTRODUCTION

Visitors to the Seattle Art Museum encounter old master paintings in the handsome modern galleries of a building designed by Robert Venturi and completed in 1991 (fig. 9). The paintings, presented in roughly chronological fashion, are seen among other objects including sculpture, porcelain, furniture, and silver from European culture before 1800. Modern museums must replace the original context of a work of art—its setting, variable light conditions, appropriateness of subject matter—with a new context that highlights certain qualities (paint texture, style, and form) at the expense of some of the artist's original concerns. This essay, designed to provide a basic introduction to the Kress Collection at the Seattle Art Museum, will supply for these paintings some of the background information that cannot be accommodated in the gallery installation. Remarks about individual works are not exhaustive. Here I am less interested in adding to scholarly debate over art historical issues than in trying to trace how these artists used their materials and vocabularies to convey particular meanings.[1]

For roughly three hundred years, from about 1200 to 1500, most European paintings were devotional objects, commissioned to occupy sacred spaces in Christian churches and private chapels. Craftsmanship and artistic skill were appreciated, but the real value of a work of art resided in the holy image itself. With the expansion of the art market after around 1500, artistic opportunities increased, and many more secular subjects, including portraits, were commissioned to decorate the homes of the wealthy. In the seventeenth and eighteenth centuries, the nobility and upper classes joined and then replaced the Church as major patrons of artists. All of these developments are reflected in the works of the Kress Collection at the Seattle Art Museum.

CHRISTIAN ART: THE LIFE OF CHRIST

The visual image of Jesus changed radically in the centuries after his crucifixion in A.D. 33. According to the Bible, Christendom's most sacred authority,

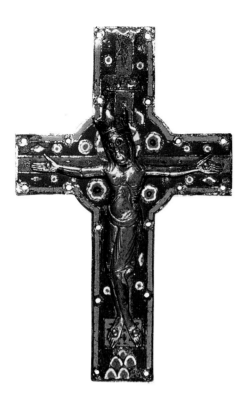

Jesus was miraculously conceived by the Holy Spirit and born of Mary, a virtuous young Jewish woman. He was both fully divine and fully human. In the earliest Christian art, made before the fourth century, it was forbidden to show his image because imagery was associated with idolatry, and also because the early Christians practiced their religion under threat of persecution. In this period Jesus was represented symbolically—as the Good Shepherd, for example. Medieval artists stressed Christ's divine authority as a way of endorsing the power of the Church and its practices; in a crucifix of around 1200, for example (see fig. 10), the crown, open eyes, and erect posture all express Christ's triumph over earthly death. In the fourteenth and fifteenth centuries, representations of Christ changed again for two principal reasons: the Church realized that identifiable imagery could help worshipers grasp abstract theological concepts, and theological literature brought a new humanity to the figure of Jesus. Thirteenth-century commentators such as the Pseudo-Bonaventure and Jacobus de Voragine had written new versions of the life of Christ and the Virgin Mary that supplied anecdotal and sentimental details missing in the spare Gospel narratives. The transformation of Jesus from an authority figure into a more accessible human being with frailties, disappointments, and close human relationships forged a stronger bond with the devout and compassionate worshiper. God the Authority was replaced in literature and art by Jesus the man (see fig. 18), a sympathetic and

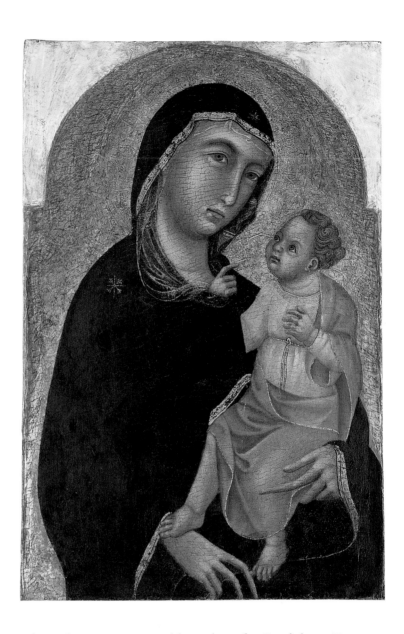

Fig. 11. Master of
San Torpè (Sienese-Pisan,
act. c. 1290–1320), *Virgin
and Child,* c. 1320. Egg tem-
pera on wood, 21⅛ x 14⅛ in.
61.152

tragic character whose fate was as inevitable as that of a Greek hero. Because
his mission was to sacrifice himself for the salvation of humanity, his story—
and his image—aroused pity, guilt, and gratitude. Orators and priests em-
ployed vivid language to excite this reaction, but for a largely illiterate
populace, images were tremendously potent.

The Infant Christ

From the thirteenth through the fifteenth century, two subjects surpassed
all others in popularity and emotional power. The first was the infant Christ
shown with Mary, an image of divine perfection and innocence that ex-
pressed a universally affecting emotional bond between mother and child.
The recognition of this familiar relationship was meant to increase the

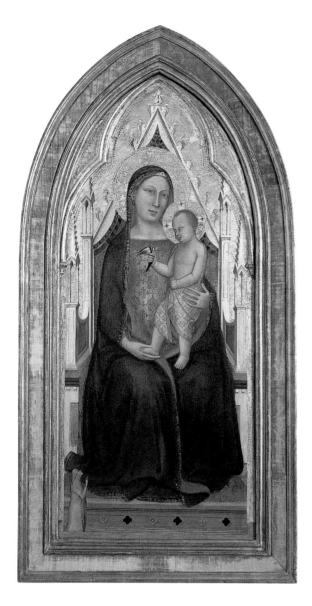

Fig. 12. Studio of Bernardo Daddi (Florentine, act. first half 14th c.), *Virgin and Child with Donor,* 1340s. Egg tempera on wood, 43 x 18½ in. 61.151

viewer's distress and sorrow on witnessing the second great subject, the death of Christ on the cross. While some Madonna and Child images simply showed the two figures against a plain background, others incorporated complex symbolic imagery that linked biblical events to larger doctrinal issues, for example the multiple roles that theologians had assigned to Mary.

Two roughly contemporary Tuscan paintings of the Virgin and Child (figs. 11 and 12) depict a lively baby with a loving relationship to his mother. Yet even in the simpler painting by the Sienese Master of San Torpè, more than the haloes indicates that the pair are no ordinary mother and child. The star on the shoulder of Mary's dark blue mantle identifies her as *Stella Maris*,[2] and she meets the viewer's gaze while protectively cradling her son to remind us of her larger role as mother of the Savior. Maternal warmth is also estab-

lished in the slightly later painting from the workshop of Bernardo Daddi (fig. 12), where the Child has the solidity and weight of a real baby. The large Gothic throne draped with a cloth of honor gives this image a greater formality and indicates Mary's designated roles as Queen of Heaven and embodiment of the living Church. The presence of the kneeling donor at the lower left, whose tiny size underscores the divinity and power of the Virgin and Child, lets us know that this is the woman who paid for this comparatively elaborate and expensive image. The unidentified donor believed that her image kneeling in perpetual prayer would document her devotion long after earthly life was over, and would speed the soul's reception into heaven. The names of the individuals who painted these two images are also unknown to us, but in the Italian workshop system, even anonymous masters produced paintings of enduring quality and workmanship for devotional reasons, for the glory of God, and out of professional pride.

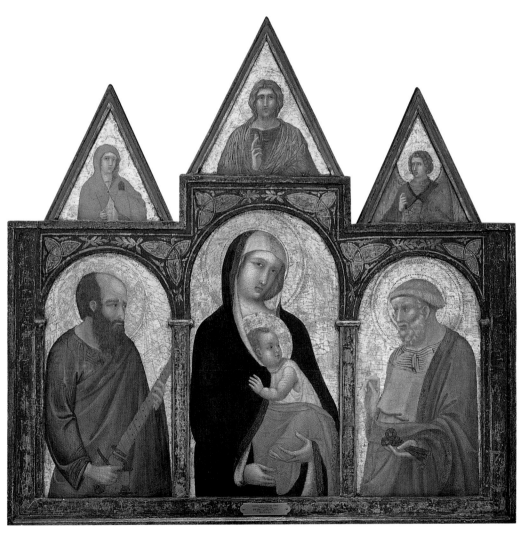

One of Siena's greatest artists went even further in humanizing the Christ Child in an altarpiece (fig. 13) that retains emotional power despite its damaged condition. In Pietro Lorenzetti's image, the Christ Child seeks protection in the folds of his mother's mantle, recoiling from the stern figure of Saint Peter. The artist wants the viewer to think of the Child as a vulnerable baby with recognizable human instincts and emotions. The Virgin's resigned expression reveals her understanding that while she can cradle and comfort her son now, she will eventually have to release him to his fate. The sense of foreboding in this depiction was taken up by other artists in subsequent years.

The pairing of the Virgin and Child with saints that we find in this altarpiece remained a common arrangement throughout the Renaissance. While a small *Virgin and Child* by Bartolomeo Vivarini (fig. 14) might appear to be an image for personal devotion, instead it probably crowned a large altarpiece of standing saints. This format was common in Vivarini's oeuvre, and the obvious perspective from below confirms that the painting was meant to be installed high above the viewer's head.[3]

Fig. 14. Bartolomeo Vivarini (Venetian, c. 1439–1499), *Virgin and Child,* c. 1490. Egg tempera on wood, 19¾ x 16½ in. 61.175

The subdued quality already seen in paintings featuring the Virgin and Child can be found in other Infancy scenes. Even the traditionally joyful Adoration of the Child could be quietly mournful. In Cosimo Rosselli's somber version of this scene (fig. 15), Mary kneels in prayer before her newborn son while the young John the Baptist (Christ's cousin and his elder by only six months) attends to Joseph, Mary's husband; Joseph was often ignored in fifteenth-century painting and is peripheral here. The Child's head is supported by two sheaves of wheat. This is a reference to the Eucharist, the Christian rite in which bread and wine are swallowed in symbolic reenactment of Christ's physical offering of his body and blood. The presence of the wheat here is a painfully prescient reminder that Christ's principal purpose is self-sacrifice.[4] Nothing in the placid landscape competes with the mood of sorrowful contemplation; in the background, the artist had drawn an angel announcing Christ's birth to the shepherds, then changed his mind and painted over it. The *pentimento*, or change of mind, has become visible again after a recent cleaning.[5]

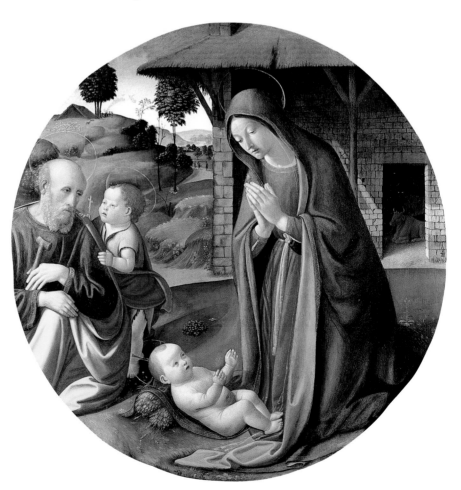

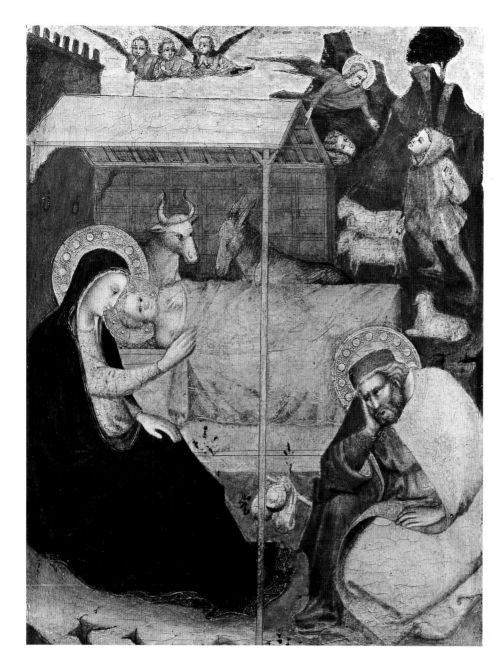

Fig. 16. Master of the Straus Madonna (Florentine, act. late 14th–early 15th c.), *Nativity,* c. 1390. Tempera on wood, 13⅝ x 10⅝ in. Private collection, Milan

Despite its gay colors and a liberal use of gold, a charming *Adoration of the Magi* by the Master of the Straus Madonna (fig. 17) also conveys solemnity.[6] The three kings, representing earthly riches and power, travel to Bethlehem to humble themselves before a greater king, the Infant Christ. Their long pilgrimage following the star over Bethlehem is suggested by the entourage of pages and pack camels winding through the craggy mountains. This subject was popular throughout the late Middle Ages and Renaissance for several political and practical reasons. The Church naturally approved of the symbolic submission of earthly powers to its authority, while patrons in

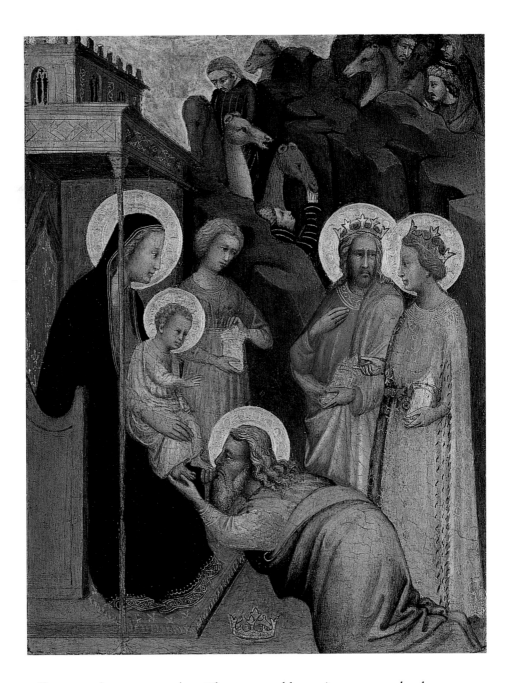

Fig. 17. Master of the Straus Madonna (Florentine, act. late 14th–early 15th c.), *Adoration of the Magi,* c. 1390. Tempera on wood, 13⅝ x 10⅝ in. 61.161

affluent trade centers such as Florence, and later, Antwerp, took advantage of the subject by having artists display all variety of material wealth and imported goods.[7] The painters, in the meantime, had an opportunity to indulge their decorative skills.

Artists often emphasized the contrast between the earthly splendor of the three magi and the humble setting of the stable where Christ was born, but the Master of the Straus Madonna chose to honor the Virgin by placing her on a draped Gothic throne similar to the one in the *Virgin and Child with Donor* (fig. 12). The brocade cloth of honor is adorned with fleurs-de-lis,

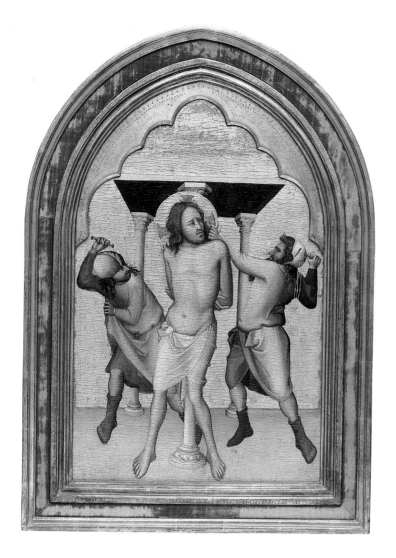

Fig. 18. Dalmasio di Jacopo
(Bolognese, act. 1350–70),
The Flagellation, c. 1360.
Egg tempera on wood,
22⅝ x 14½ in.
61.147

symbol of the city of Florence. The artist's decision to formalize the stable setting is better understood when we imagine this painting beside its original mate, now in a private Italian collection (fig. 16). In the *Nativity,* the Master of the Straus Madonna dutifully shows the modest surroundings of Christ's birth; in the *Adoration,* the artist pays Christ the respect due a king. This nuance of interpretation is lost when the two works, once part of a devotional diptych, are separated.

With the rise of art collecting in the last two hundred years, multi-paneled altarpieces designed for worship or to enlist divine intercession were often dismembered, like this diptych, and their parts sold separately. This was the fate of many of the paintings that became part of the Kress Collection, which was assembled in the early twentieth century when this practice was at its height. According to the fashion of the day, individual panels were frequently mounted in velvet-lined frames (see fig. 18) with identifying

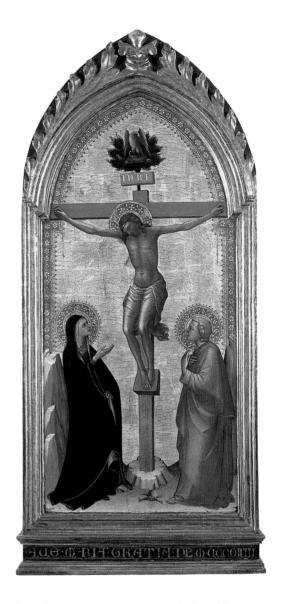

Fig. 19. Lorenzo Monaco and workshop (Florentine, c. 1370–1425), *Christ on the Cross with the Virgin and Saint John,* 1408. Egg tempera on wood, 49½ x 23½ in. 61.158

plaques. The fragmentation inevitably altered the meaning and visual impact of these paintings. But since subject matter was largely ignored in art historical writing at this time, the dispersal of parts of a single altarpiece was not regarded as an injustice against meaning until some years later.[8]

The Adult Christ

The Bible describes the adult Jesus as a charismatic teacher who performed healing miracles and professed loyalty only to a higher power. As such he was a threat to the Roman government and religious authorities in Jerusalem. At the age of thirty-three, he was arrested and sentenced to be crucified, a shameful death reserved for society's lowest criminals. According to the Gospels, three days after his death he was miraculously resurrected and remained on earth for forty more days before ascending to heaven, not to return until

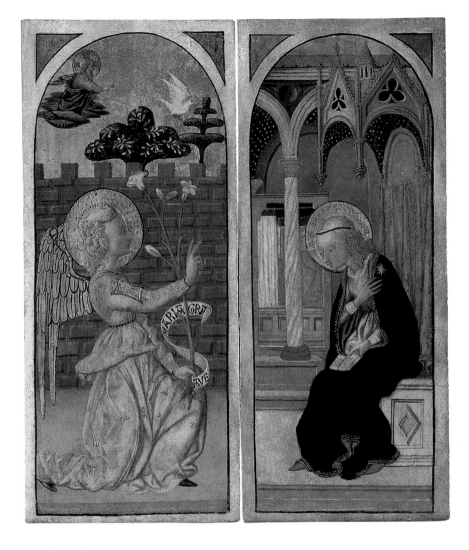

Fig. 20. Master of Fucecchio (Tuscan, act. mid-15th c.), *The Annunciation,* c. 1440. Egg tempera on wood, left panel: 18 x 7 in.; right panel: 18 x 7½ in. 61.159

the day of the Last Judgment. His triumph over death is the basis for the Christian belief in salvation.

Medieval and Renaissance artists, however, devoted less attention to Christ's teaching and even his ultimate victory than to the last week of his life, a series of episodes that are collectively called the Passion of Christ. The many scenes of mocking and torture were documented in painful detail to arouse compassion and guilt in the viewer. *The Flagellation,* a painting by the Bolognese painter Dalmasio di Jacopo (fig. 18), for example, depicts the whipping to which Christ was subjected after his arrest. Because of his claims to be the Son of God, he was ridiculed, stripped, and beaten by soldiers of the Roman governor, Pontius Pilate. Dalmasio pared down the episode to its violent essentials—the column to which Jesus is lashed and two vigorously enthusiastic tormentors. Even this minimal presentation was capable of arousing strong emotions among worshipers. Though now retouched, the

eyes of the torturers were once gouged out by viewers, a common fate for evildoers in Christian art.[9]

The omnipresent Christian image is the Crucifixion itself, the figure of a man dying on a cross, which bears witness to Christ's human suffering and is a stirring, lasting symbol of his sacrifice. The Florentine painter Lorenzo Monaco presents the event timelessly, leaving out the historical details of onlookers, the two thieves who were crucified with Christ, and Jerusalem in the distance (fig. 19). Christ's lifeless body hangs from the cross against a gold distance. Thin streams of blood drip from the nail holes in his hands and feet, and his body is drained of color. Flanking the cross are his mother and Saint John the Evangelist, whom he charged from the cross to care for each other. His survivors do not display tortured expressions of grief, which we often see in this scene, but serene acceptance and reverence—models for the viewer to follow.

The painting is in its original frame, which bears an inscription and the date 1408: "Ave Maria Gratia Pl[ena] MCCCCVIII." The text, which translates "Hail Mary, full of grace," is from the Angel Gabriel's salutation to

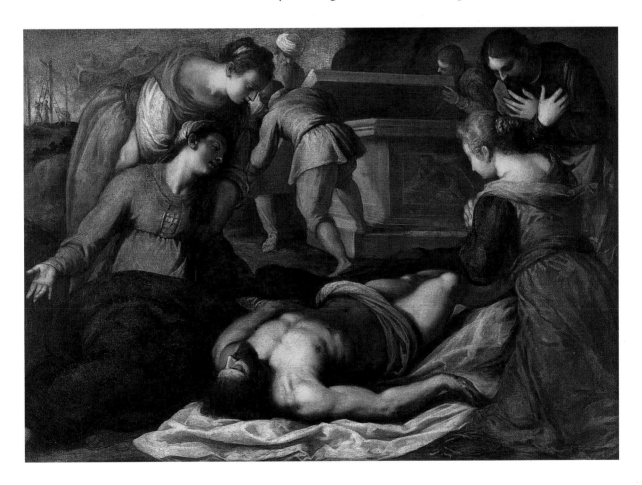

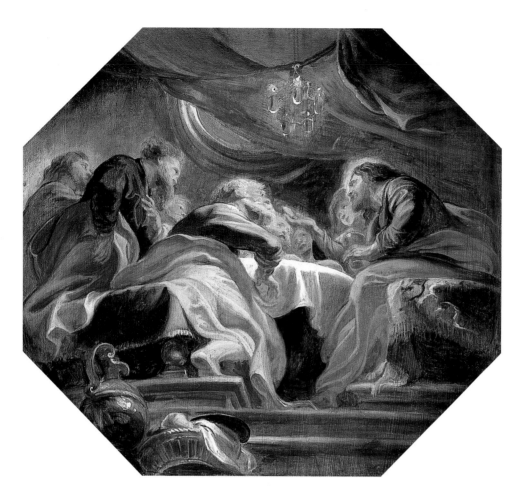

Fig. 22. Peter Paul Rubens
(Flemish, 1577–1640),
The Last Supper, 1620.
Oil on wood, 16⅞ x 17 in.
61.166

Mary during the announcement that she has been chosen to be the mother of the Savior (fig. 20)—a courtly, decorative rendering of that episode attributed to the Master of Fucecchio. The prominent inscription is good evidence of the Virgin's popularity, which during this period rivaled that of her son.

In the medieval period, it was common to show the Passion episodes in sequence to create a mounting dramatic and emotional effect. Dalmasio's *Flagellation* may have been part of such an altarpiece. In the sixteenth century, artists were more likely to concentrate on a single episode rendered in heroic scale, to suit the proportions of Renaissance classicizing architecture. The Venetian painter Jacopo Palma devoted a vast canvas to the *Lamentation over the Dead Christ* (fig. 21), the moment when Jesus's mother and closest followers mourn his unjust death. While workers efficiently prepare Christ's tomb, his mourners, on either side of Christ's sharply foreshortened body, assume attitudes of grief and veneration. The presence of the body on the white shroud near the painting's lower edge would have had extra symbolic impact if the painting were intended as an altarpiece. During mass on the altar directly below the image, the host of the Eucharist would be kept under a white cor-

poral, or covering cloth, until it was distributed. For worshipers who believed the doctrine that the host was the actual body of Christ, the parallel would have a powerful impact.

The institution of the Eucharist is the subject of Peter Paul Rubens's oil sketch (fig. 22), designed in 1620 for an octagonal ceiling painting to be installed in a new Jesuit church in Antwerp. While earlier depictions of the Last Supper often focused on Christ's announcement that one of his disciples would betray him, Rubens emphasizes the ecclesiastically important moment when the rite of the Eucharist is enacted for the first time. Grasping the wine chalice in his left hand, Christ holds up a piece of bread as he recites:"This is my body which is given for you: this do in remembrance of me" (Luke 22:19).

Colored oil sketches like this one served as models for the artists in Rubens's workshop (including Anthony van Dyck) who were hired to paint

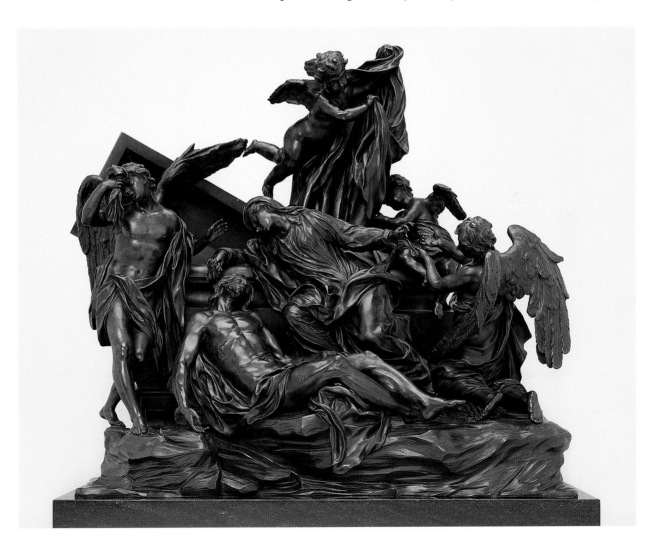

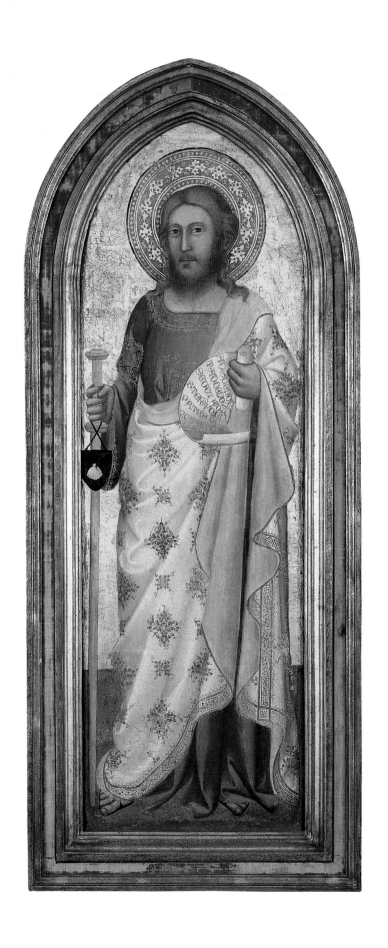

the large-scale ceiling paintings from his designs. The sketches themselves
were so prized that Rubens chose to keep them himself and paint another
altarpiece for the church rather than turn them over as part of the commis-
sion. The only part of the ceiling project wholly by the master's own hand,
the surviving sketches now also constitute the major evidence for the cycle,
which was destroyed when the church suffered a devastating fire in 1718.[10]

The fluid lines and swift movement carried from one figure to another,
which unite the composition, are also qualities found in a *Lamentation* by the
Florentine sculptor Massimiliano Soldani (fig. 23). Where the *Lamentation* by
Jacopo Palma showed a variety of responses to Christ's death, this work is a
supremely theatrical, even operatic, display of unified grief as Mary swoons
over her son, and an angel turns his head to wipe away tears. The parallel
figures of Christ and Mary are encircled by the busy putti who prepare the
shroud, and two flanking angels, one of whom would have received the crown
of thorns (now lost) from Mary. Soldani was one of the leading sculptors in
bronze in eighteenth-century Florence. He began his career as a medalist and
was master of the mint for the grand dukes of the Medici family. His early
work in relief gave way to more complicated freestanding pieces; this *Lamen-
tation* is one of his most complex and successful works. Despite its subject, it
was probably made for a collector rather than a church; in the eighteenth
century it was owned by the counts of Bardi, of Florence.[11]

CHRISTIAN ART: SAINTS

The cult of saints—characters whose good works, Christian devotion, and
martyr's death earned them special reverence by the Church—arose in the
Middle Ages and flourished throughout the Renaissance. Their attractive
stories—a dissolute life renounced for poverty and dedication to Christian
service (Saint Francis), a devout princess imprisoned and later murdered by
her nonbeliever father (Saint Barbara)—appealed to popular imagination.
Though saints were not worshipped, they could be called on to intercede or
to offer protection from various dangers. Relics of the saints were preserved
and venerated. Much church decoration was devoted to the saints, who as
single standing figures also often constituted a supporting cast for images of
the Virgin and Child.

A beautiful image of Saint James (fig. 24) may be tentatively attributed
to Alegretto Nuzi, a fourteenth-century artist who was influenced by Pietro
and Ambrogio Lorenzetti of Siena as well as the Florentine artist Bernardo
Daddi (see figs. 13 and 12). The suave coloring and mastery of decorative

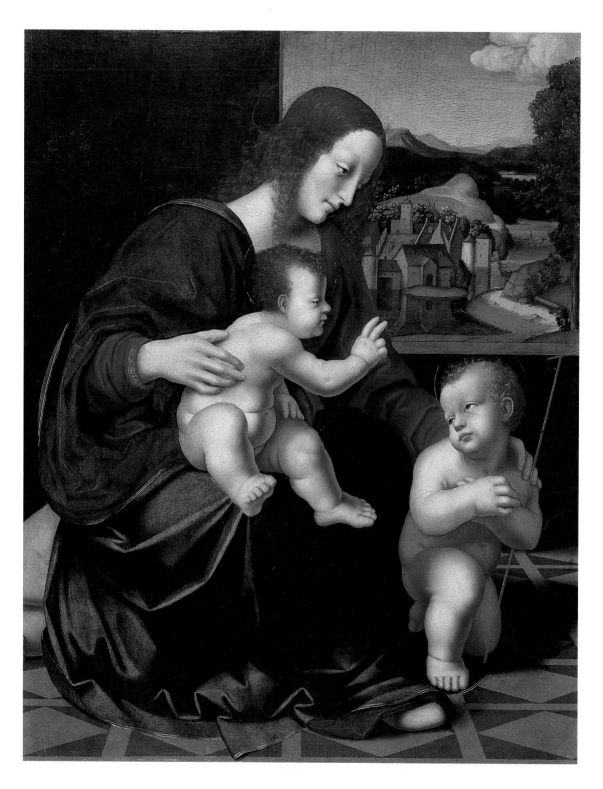

Fig. 25. Marco d'Oggiono
(Milanese, c. 1467–1524),
*Virgin and Child with Saint
John the Baptist*, c. 1505–10.
Oil on wood, 36¾ x 30¾ in.
37.57

Fig. 26. Gian Antonio Guardi
(Venetian, 1699–1760/61),
*Holy Family with Saint John
the Baptist and Saint Catherine
of Alexandria,* c. 1750.
Oil on canvas, 23⅞ x 27 in.
61.155

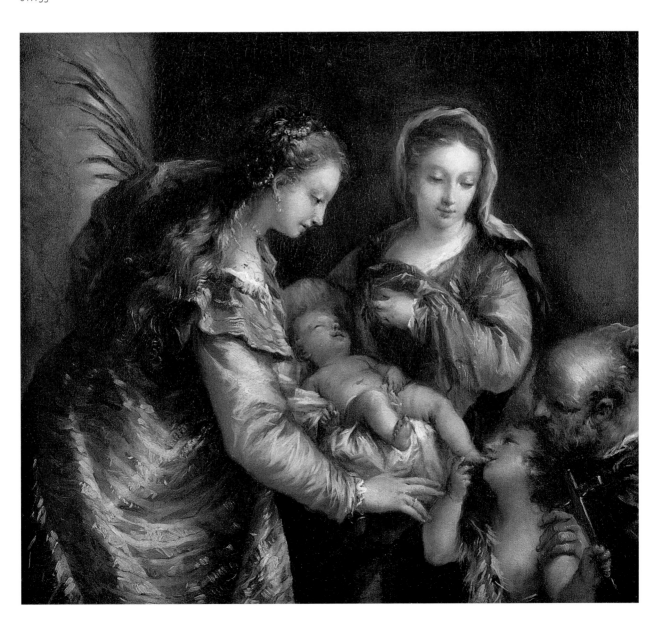

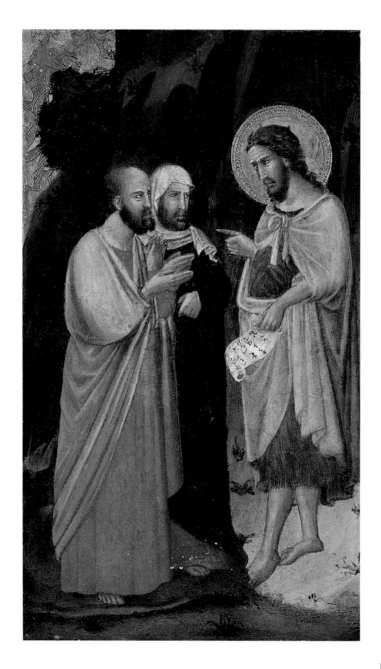

Fig. 27. Master of the Life of
John the Baptist (Riminese,
act. first half 14th c.), *Saint John
the Baptist Meets Two Pharisees,*
c. 1340. Egg tempera on wood,
11⅛ x 7¼ in.
61.160

details—stenciled pattern on the white robe, gilt simulated embroidery, inscription on the scroll, and punchwork of the halo—suggest that the original altarpiece from which the painting came must have been magnificent.[12] The saint holds a pilgrim's staff hung with a wallet showing a scallop shell. These refer to James Major's legendary mission to Spain; his supposed burial site at Santiago de Compostela in the northwest corner of Spain is still one of the central sites of Christian pilgrimage.

If not for these familiar attributes, the figure might as easily be identified as Saint James Minor, the putative brother of Christ. James was said to physically resemble Christ, as this figure does, and the lines from the Apostles' Creed shown on the scroll had been assigned to James Minor in the sixth century.[13] The refined garments are closer to this saint's frequent costume of episcopal robes (he was the first bishop of Jerusalem) than to James Major's customary heavy brown pilgrim's robe. The apparent conflation of the two Jameses is unusual, and it remains inexplicable because the original altarpiece has been dismantled.

John the Baptist was especially prominent in Christian thought and imagery, and like Christ, he was depicted at all stages of life from infancy to death. The son of Mary's cousin Elizabeth, John was only six months older than Jesus. In Italian painting he is frequently seen as a baby in the company of members of the Holy Family. In Marco d'Oggiono's painting (fig. 25), for example, the two babies are endowed with the mature prescience of their adult roles. Wearing a melancholy expression, John kneels in adoration of Jesus, who blesses him. In a much later painting by the Venetian artist Gian Antonio Guardi (fig. 26), John kisses Christ's foot, but in a more childlike way. Mary and Joseph and Saint Catherine of Alexandria witness this demonstration of filial love.[14] Guardi copied the composition from a sixteenth-century painting by Paolo Veronese, now in the Uffizi Gallery, in Florence.

John the Baptist's eventful life, which included retreat into the wilderness, preaching about Christ's coming, baptizing Christ, and dying by beheading, was sometimes the subject of narrative altarpieces. The small painting of John the Baptist meeting two pharisees (fig. 27) is a fragment of a panel from a now-dispersed altarpiece of around 1340 by the Master of the Life of John the Baptist, the principal work attributed to this artist from Rimini. Eight narrative scenes once flanked a large image of the Virgin and Child.[15]

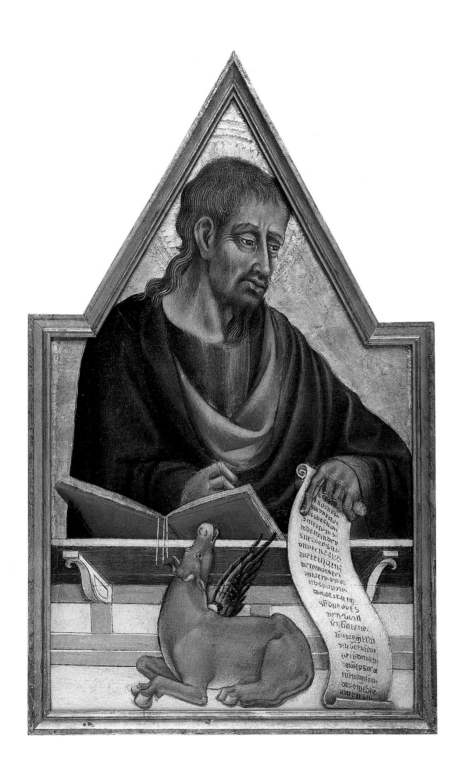

Fig. 28. Giovanni di Paolo
(Sienese, 1403–1483), *Saint
Luke the Evangelist*, c. 1470–75.
Egg tempera on wood,
22 x 13½ in.
61.154

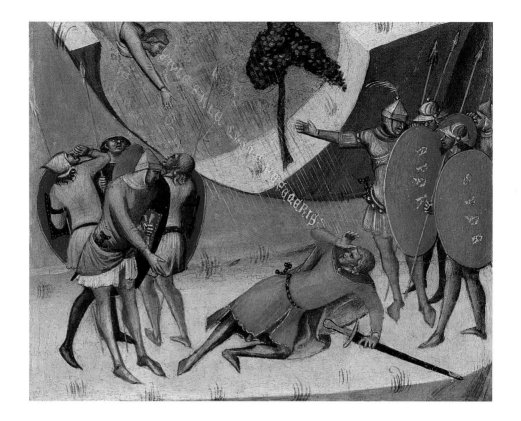

Fig. 29. Luca di Tommè (Sienese, act. 1356–1389), *The Conversion of Saint Paul,* c. 1380–89. Egg tempera on wood, 12⅜ x 15¼ in. 61.167

The scale and shape of an isolated panel, as well as the subject, can offer clues to its original disposition. For example, the steeply gabled panel of Giovanni di Paolo's *Saint Luke* (fig. 28), showing the underside of the saint's lectern, must have been a pinnacle from an altarpiece. It shared the upper register with similar panels showing the other three Evangelists—Matthew, Mark, and John.[16] A small rectangular panel by Luca di Tommè (fig. 29) was a predella panel from a large altarpiece. In Italy the predella, the lower plinth of the altarpiece, consisted of a series of small rectangular images that were often devoted to narrative episodes relating to the main figures of the altarpiece. Because of the subordinate position and size of these images, artists could exhibit more drama and compositional innovation than was possible in the more prominent and conservative central zone. This panel shows the dramatic moment when the unbeliever Saul was struck by a sudden blinding vision from heaven and heard God's voice saying, "Saul, Saul, why do you persecute me?" (Acts 9:4)—visible here as text running from heaven to earth. This dramatic episode converted Saul, and as the Christian apostle Paul he became the most important proselytizer to the non-Jewish world.[17]

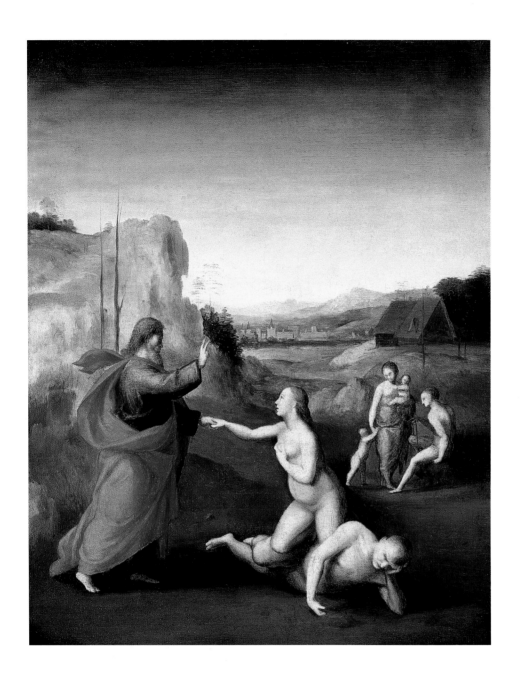

Fig. 30. Fra Bartolommeo
(Florentine, 1472/5–1517),
The Creation of Eve, c. 1510.
Oil on wood, 12⅝ x 9¾ in.
61.145

Images showing stories from the Old Testament, the holy scripture written before Christ's birth, are rarer in European art than scenes from his life. For medieval commentators, the events of the Old Testament, and its highly metaphorical language, were interesting chiefly in providing a typology for the events of the New Testament. For example, the Book of Genesis recounts how Abraham, victorious in battle, was met on his return by the high priest Melchizedek, who brought out bread and wine and blessed Abraham. In the Middle Ages this episode was considered to be significant primarily as a prefiguration of the Last Supper over which Jesus presided, and which became the central sacrament of the Church.

In this vein, medieval art usually depicted the first man and woman, Adam and Eve, as the first sinners. Their human susceptibility to temptation led to the Fall of Man and created the need for Christ's incarnation and death. By the Renaissance this pessimistic, negative view was challenged by artists. The Dominican friar Fra Bartolommeo's small image *The Creation of Eve* (fig. 30) instead portrays their existence as hopeful and positive and emphasizes their closeness to God. In this early, perfect world, nudity is associated with purity rather than shame, as it will be after the Fall. Fra Bartolommeo closely follows the account from the Book of Genesis. On the sixth day of creation, after making the plants and animals, God created the first man, Adam, and soon decided that he needed a companion. While Adam was sleeping, God created Eve from Adam's rib. Here we see Adam in a deep trance as the robed figure of God helps Eve emerge from Adam's side. In the background is a scene from a later time, Adam and Eve with their sons Cain and Abel. The purpose of this sketchily painted panel is not clear, but it may have been a model for a larger painting.[18]

Another Old Testament subject, *Hagar and the Angel,* shown here in a painting by the Genoese painter Bernardo Strozzi (fig. 31), became popular in the seventeenth century. After many years of marriage, Abraham and Sarah were unable to conceive a child, so Sarah offered Abraham her Egyptian maid Hagar to provide him a child. Hagar gave birth to a son named Ishmael. Several years later, Sarah herself gave birth to Isaac and had Abraham banish Hagar and Ishmael to the desert. When their food and water ran out, Hagar put her child under a bush so she would not see him die. His cries were heard by God, who sent an angel to deliver the pair. A well miraculously appeared in the desert, and Hagar was able to quench her son's thirst

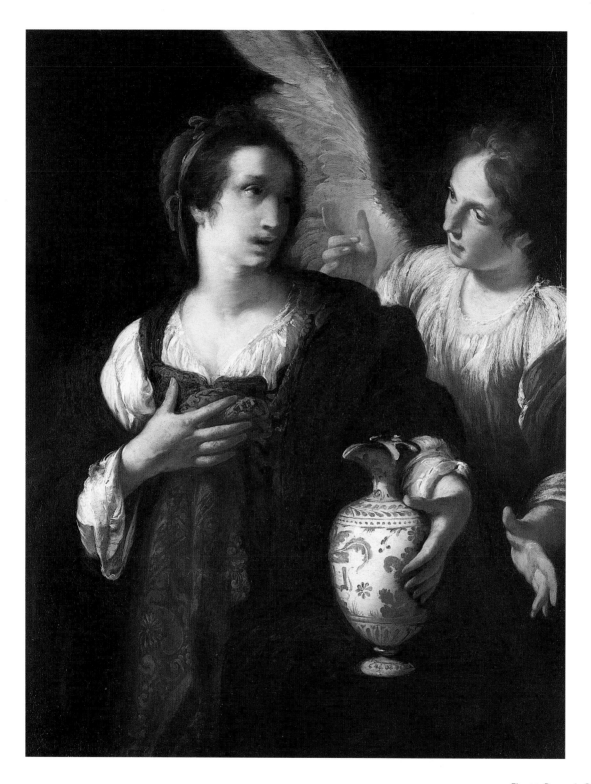

Fig. 31. Bernardo Strozzi
(Genoese, 1581–1644),
Hagar and the Angel, c. 1630.
Oil on canvas, 48⅞ x 37 in.
61.168

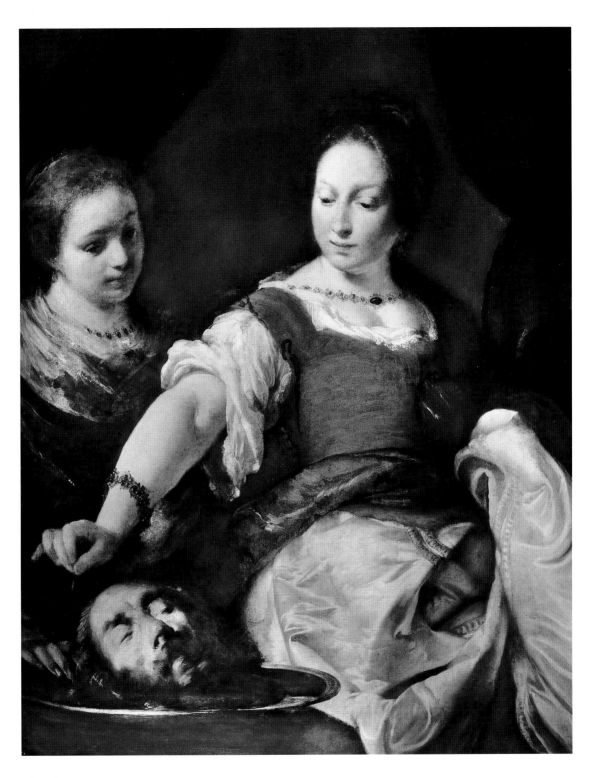

Fig. 32. Bernardo Strozzi
(Genoese, 1581–1644),
*Salome with the Head of
John the Baptist*, c. 1630.
Oil on canvas, 48⅞ x 37 in.
Staatliche Museen,
Gemäldegalerie, Berlin

and keep him alive. The painting's obscure setting focuses the viewer's attention on the interaction between the angel, who has just appeared, and the weary Hagar, who had given up hope. We see no indication of either the desert or of Ishmael. Only the water jug and the edge of a well on which it stands confirm the identities of the figures as Hagar and the angel. Otherwise we might identify them as the New Testament figures of Mary Magdalene and the angel who tells her of Christ's resurrection early Easter morning. In that case the well would have been interpreted as the edge of Christ's tomb and the water jug as Mary's jar of ointment.

In fact, a painting of this size, recorded in an early eighteenth-century inventory from Genoa, was actually identified as *Mary Magdalene with the Angel*. It was one of a pair; the inventory identified the other painting as *Judith and Her Servant with the Head of Holofernes*, a familiar Old Testament subject. A painting fitting this description and the Seattle painting were both owned by a Roman dealer until 1914, when the first work was purchased by the Staatliche Museen, Berlin (fig. 32). To complicate matters further, the Berlin painting is now instead called *Salome with the Head of John the Baptist*, which turns the protagonist from an Old Testament heroine defending her virtue and rescuing her people from an oppressive tyrant, into a New Testament seductress responsible for the death of a great prophet.

Confusion over the subjects of these two paintings would not exist if the artist had chosen to include more narrative details. We should not necessarily trust the reliability of the identifications in the eighteenth-century inventory; early inventories based on visual description alone are notoriously unreliable. As for the expectation of some thematic connection between two paintings designed as a pair, there is no obvious relationship between Hagar and Salome except that both were exploited by other women (Sarah and Herodias) more powerful than they. Whatever the proper identification of subject matter, we must assume that the patron was satisfied with a minimal presentation that focused on the characters' emotional responses rather than narrative authenticity.

MYTHOLOGY, ALLEGORY, AND LANDSCAPE

By the sixteenth century, churches and noble homes were no longer the exclusive sites for paintings. With the global expansion of trade routes and the establishment of an international mercantile and banking community, more individuals built personal fortunes and grand residences, and supported an exploding art market. Greater numbers of paintings were available in a

broader range of quality and price. In seventeenth-century Holland and Flanders, for example, many artists sold their art on the open market, not unlike today. Artists developed specialties to distinguish their work from that of their rivals. Different cities became associated with particular subjects, and artists often moved around, both to explore new styles and subjects and to tap into new markets. Scenes from secular literature became popular, especially classical themes treating the exploits of the gods.

A long, narrow panel showing battle scenes (fig. 33) was originally part of a piece of furniture called a *cassone*, or marriage chest. In fifteenth-century Italy, such chests were often commissioned by the groom, not the bride, which may account for the common use of military rather than amorous themes to decorate them. Traditionally this theme has been identified as being episodes from the myth of Theseus, the legendary Greek hero, primarily because the battle scene at the right, between soldiers and woman warriors, was thought to represent Theseus's battle with the Amazons. But if we assume a single narrative direction, other episodes are more difficult to reconcile with the myth of Theseus. Recently a scholar has proposed a more successful identification of the subject as episodes from Virgil's *Aeneid*.[19] She identifies the far left scene as Aeneas and Achates greeting King Evander, Pallas, and the court. In the middle ground, preparations are made for a feast in honor of Hercules. At the right, the four women fight the Trojans.

The condition of the painting has made a secure attribution difficult. As a *cassone* panel, it was mounted on a chest near the floor and has the scratches and gouges that one would expect to see on a piece of furniture. In addition, the armor of applied silver leaf, originally worn by many of the figures, has oxidized and darkened, leaving indecipherable black lumps, especially at the right. Well-preserved areas show a high level of workmanship and care, for example in royal garments where rosy glazes are brushed over punched gilding (fig. 34). In its original state, the panel would have glittered with lively narrative incident and flashing surface effects. This high quality has led some scholars to attribute the painting to one of the greatest Florentine masters of the fifteenth century, Paolo Uccello.[20]

When large decorative paintings were required for important domestic interiors, patrons commissioned frescoes, painted directly on the wall, or large canvases, which came into widespread use in the sixteenth century. Canvas was especially popular in Venice, where its rough weave was incorporated into a painting style that celebrated texture and prominent brushwork. The new support, lightweight and portable, could be used for large-scale projects

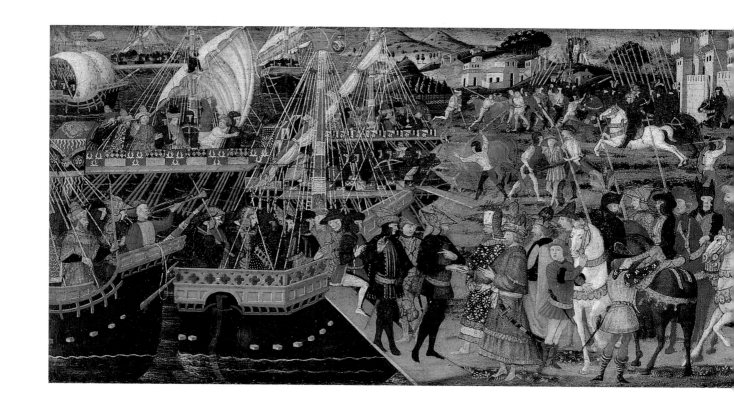

Fig. 33. Attributed to Paolo
Uccello (Florentine, c. 1397–
1475), *Episodes from the
Aeneid*, c. 1460. Egg tempera
on wood, 16⅛ x 61½ in.
61.173

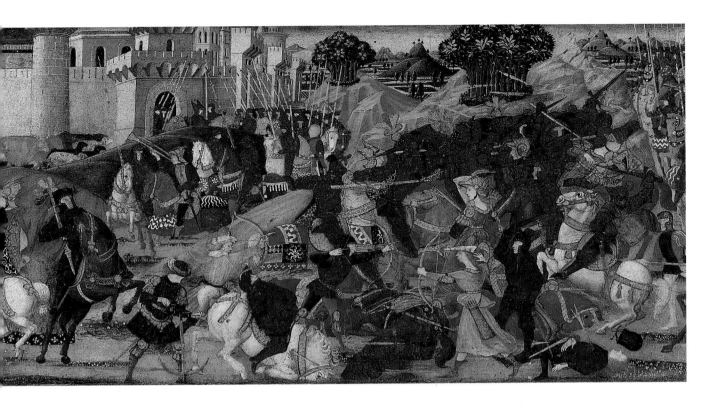

Fig. 34. Detail of fig. 33,
Paolo Uccello, *Episodes
from the Aeneid*, c. 1460

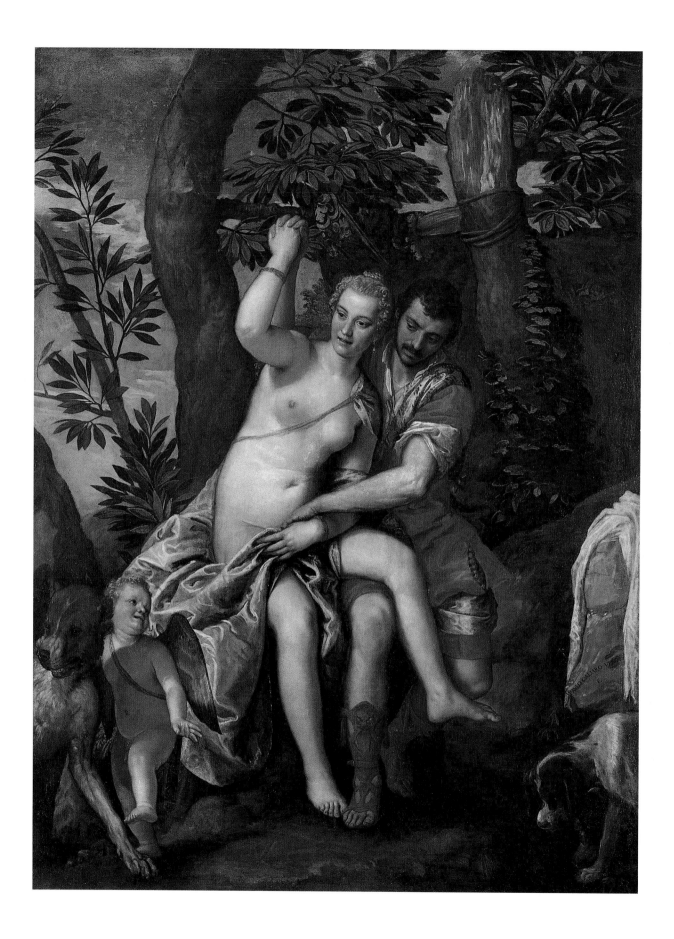

Fig. 35. Workshop of Paolo Veronese (Venetian, 1528–1588), *Venus and Adonis,* signed "PAULO CALIARO VEROES F.," c. 1578. Oil on canvas, 88⅜ x 66¼ in. 61.174

without the extensive and costly preparation necessary for wooden panels, until then the most common painting surface. It was now easy for foreign patrons to order paintings from masters in other cities because the pictures could be rolled and easily transported great distances; this practical advantage must have contributed to the increasingly international reputations that more and more painters enjoyed. It has been suggested, for example, that the *Venus and Adonis* (fig. 35) was ordered from Paolo Veronese, working in Venice, by the Emperor Rudolph II, who was based in Prague. Veronese was in international demand for his images of idealized religious or mythological figures rendered in beautiful hues; the lavender of Venus's drapery and the apricot tunic worn by Adonis are typical of his palette. By the time Veronese was active, the nude had become an acceptable and even desirable subject, and the increased scale provided by canvases allowed him to paint life-size, heroic figures who were the epitome of female and male beauty.

Struck by Cupid's arrow, Venus conceived a helpless passion for the handsome Adonis, who was later killed by a wild boar while hunting. The lovers' brief time together is presented as a period of happiness shortly to be interrupted by tragedy—suggested by the presence of the two hunting dogs that will soon urge their master away. The myrtle tree is a double reference to Adonis's miraculous birth after his mother had been changed to a myrtle tree, and to eternal love, traditionally associated with Venus. The broken tree trunk seems an ominous symbol of the lovers' imminent separation.

The subject and size of this work relate to other compositions painted for Rudolph II. The temporarily perfect world of the beautiful lovers is realized through the serene setting—a protected bower—and their entwined bodies. Compared to works securely attributed to Veronese, however, this painting exhibits passages of awkward drawing not typical of the master: Adonis's left arm does not properly meet his shoulder, and Venus's right arm is almost dislocated. There is also a surprising psychological disjunction between the figures, despite their entwined bodies. Venus smiles absently, ignoring Adonis's determined efforts to dislodge her hand from its gesture of modesty. Some of these problems are no doubt due to condition; the design of the brocade hanging behind the figures is all but obliterated, and losses of glazes in the foreground have compromised the illusion that the two principal figures have weight: their feet seem to float above the ground instead of resting on it.[21]

The solid figure of Cupid, who balances happily on one foot at lower left, is more carefree than the sculpted marble figure attributed to Giovanni

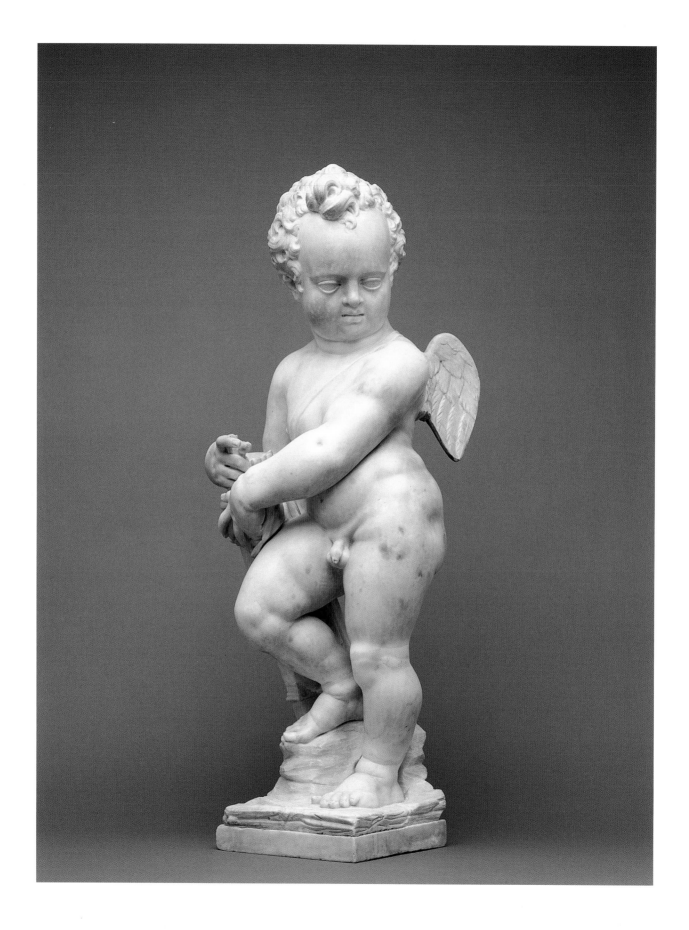

Bologna (fig. 36) from around 1580. Despite a babyish chubbiness, the young god of love has a surprisingly mature and robust expression. He balances on a rocky support, leaning on a quiver of arrows that hangs from the strap across his chest. Though the sculpture of classical antiquity can be considered the ultimate source for this figure, the energetic torque of the body that gives it visual interest from every angle is an innovation of the High Renaissance, seen for example in the *David* of Michelangelo. The wings, too small for the figure, were added later.

Veronese's *Venus and Adonis* may have been part of a mythological cycle meant for a single gallery. Such grand conceptions were common throughout Europe, and painters routinely designed canvases to accommodate specific architectural settings. In 1551 Veronese had been commissioned to paint full-length portraits in trompe-l'oeil niches for the Porto family palace in Vicenza, a structure designed by Palladio in 1548–52. Two centuries later, around 1757, the Porto family called on the greatest Venetian painter of the eighteenth century, Giovanni Battista (Giambattista) Tiepolo, to expand the decorative program in the palace. With his characteristic swift style, Tiepolo painted a sketch (fig. 37) for a ceiling fresco glorifying the bravery of a family noted for generations of military prowess. Seated in the clouds, the old man in gold, accompanied by a lion and holding a scepter in his right hand, is the allegorical figure of Valor. Fame, hovering above, crowns him with a laurel wreath. Below, the vanquished figure of Time is powerless, his scythe overturned. Together the figures represent *The Triumph of Valor over Time*, that is, the undying fame of celebrated courage.[22] The fresco (fig. 38) was detached in 1910 and remounted on canvas by the Berlin collector Dr. Eduard Simon, who installed it in his dining room with six monochrome paintings also removed from the Porto palace.[23] Painted by Tiepolo's son Domenico, they showed past generations of military heroes of the Porto family. The monochrome paintings and the ceiling fresco, which shared a common theme, were installed in the reception hall of the Porto palace and were accompanied by three smaller paintings showing architectural decorative motifs.[24]

Given its history (among other indignities, the work endured a hole cut into the middle to make room for a chandelier in Dr. Simon's dining room), it is understandable that the ceiling painting has suffered and lacks the freshness of the sketch. Some of its problems, notably the disjointed head of the putto in the upper zone, can be attributed to condition. The sketch's tight energy is also lacking in the fresco; the figure of Fame now floats far away from Valor, whose gaze, merely stern rather than intense, no longer meets the

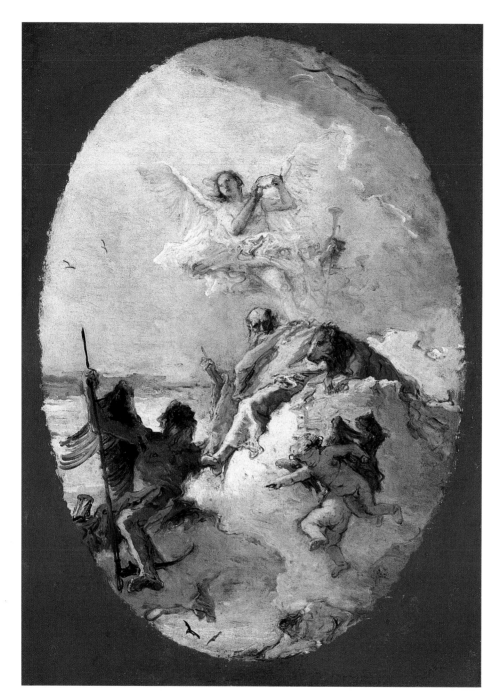

Fig. 37. Giovanni Battista
Tiepolo (Venetian, 1696–
1770), *The Triumph of Valor
over Time*, c. 1757. Oil on
canvas, 23½ x 17 in.
61.170

Fig. 38. Giovanni Domenico
Tiepolo (Venetian, 1727–1804),
The Triumph of Valor over Time,
c. 1757. Fresco transferred to
canvas, 200 x 117⅞ in.
61.169

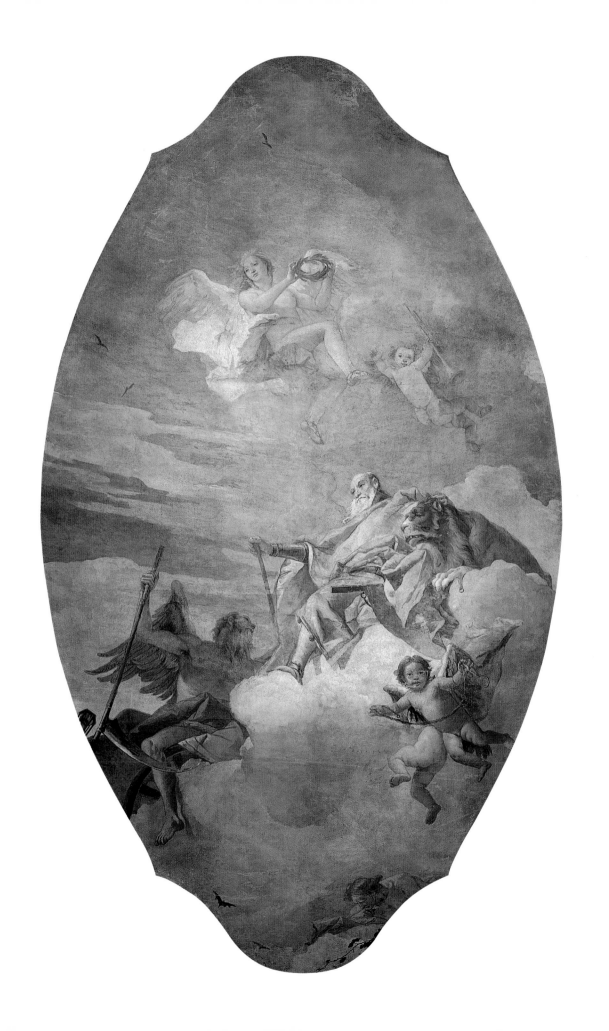

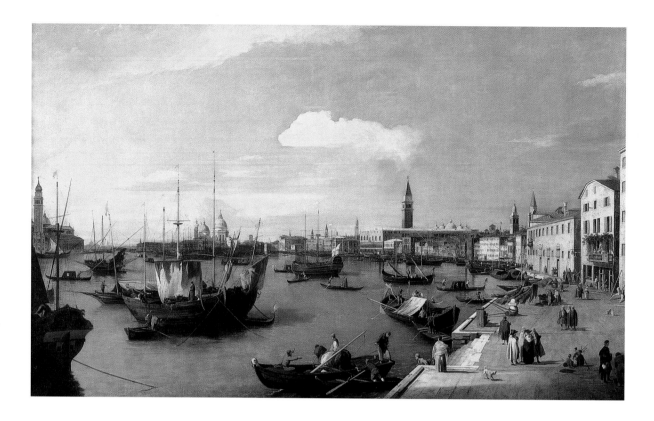

eyes of the viewer. The flatness is uncharacteristic of Giambattista's work but can be found in paintings by his son Domenico. It may be that Giambattista, who was in great demand, carried out the initial design and provided the sketch as a model for his son to follow so that he himself could meet the pressure for other commissions.[25]

Another Kress painting that passed through the collection of Eduard Simon was a view of the Bacino di San Marco from the studio of Giovanni Antonio Canal, better known as Canaletto (fig. 39). It was probably painted after 1730, when the English diplomat and collector Joseph Smith had begun marketing Canaletto's Venetian views to English clients.[26] In response to the increased demand, Canaletto established a studio that produced many versions of popular compositions. At least ten versions of this composition are known.[27]

The grand themes and views that we find in Italian baroque art are rare in seventeenth-century Dutch painting. Dutch painters specialized in relatively small-scale works that would fit within the modest proportions of most Dutch domestic architecture. Popular proverbs and folksy themes were more likely than classical myths to be the subjects of paintings intended for the wealthy burgher class. With scenes from everyday life, recognizable landscapes, and architectural views, Dutch baroque painters specialized in creat-

Fig. 39. Workshop of Giovanni Antonio Canal, called Canaletto (Venetian, 1697–1768), *Bacino di San Marco,* after 1730. Oil on canvas, 49¼ x 80¼ in. 61.148

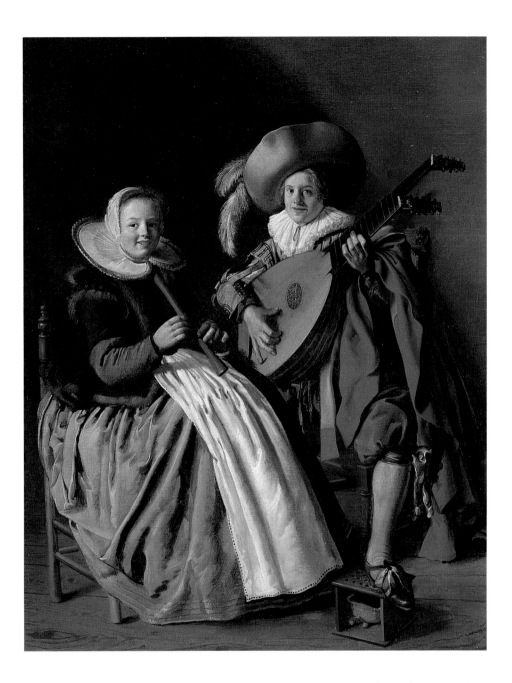

Fig. 40. Jan Miense Molenaer
(Dutch, c. 1610–1668), *The
Duet*, signed on footwarmer
"I. Molenaer," c. 1629.
Oil on canvas, 26⅛ x 20½ in.
61.162

ing the illusion of palpable reality, incidentally celebrating the rich material
culture that was a result of Holland's great economic prosperity and com-
mand of world trade.

Jan Miense Molenaer's *Duet* (fig. 40) of around 1629 shows an engaging
couple who interrupt their music-making to acknowledge the viewer. The
pleasantly informal air results from many calculated choices the artist made:
oblique placement of the figures, bare setting, and fanciful costumes. Often
the objects in Dutch paintings have symbolic meaning, but here the musical
instruments may simply suggest the harmony of a love match. The prominent

footwarmer has sometimes been interpreted as a symbol of erotic love, but Molenaer included it in many other paintings with varying subjects, and it is more likely that, like the chairs and even the costumes of the figures, it was a convenient studio prop.

One source of pleasure in this picture is Molenaer's own delight in the activity of painting. The slanted light gave him the opportunity to show areas of brightness and deep shadow and excitingly reflective fabrics, such as the green skirt that shimmers with yellow highlights. In shading the man's red cloak, Molenaer became a draftsman, creating shadows by hatching black strokes on the surface of the red paint. For the plumes and the man's hair, he removed paint by scraping through it with a stiff instrument. This extensive manipulation of the medium would have made this work an ideal object for a patron who was a connoisseur of painting, but we do not know who owned the painting before the twentieth century.[28]

Gerrit van Honthorst's *Shepherdess Adorned with Flowers* (fig. 41) is less straightforward but also captivating. A radiant young shepherdess grasps her crook and gazes dreamily as she is bedecked with flowers by two companions. She may be a bride, or simply a girl marking another kind of romantic threshold. The tender ministrations of her companions are offset by the broad grin of the shepherd, who observes the ritual with amusement from the shadows. It may surprise us to realize that this bucolic scene takes place not outdoors but against a painted ochre backdrop. Such playful dislocation is not uncommon in the genre of pastoral painting, which often has an air of artificial innocence. The celebration of unencumbered rural life as a haven from sophisticated urban activities had been a staple of European literature since Theocritus (third century B.C.) and Virgil (70–19 B.C.) and was fashionable again among seventeenth-century Dutch aristocrats. Pastoral paintings adorned both country and city homes; this work may actually have been painted to hang above a mantel in the living quarters of the Prince of Orange in The Hague. [29]

A painting intended for the aristocracy could sidestep the moral strictures inherent in Dutch society's traditional values of understatement and simplicity, which were usually reflected more directly in images painted for the general market. The seventeenth-century genre of architectural painting, for example, overtly celebrated Dutch piety or civic prosperity. Emanuel de Witte specialized in church interiors like that shown in figure 42. A whitewashed Protestant church, stripped of all but its stained-glass imagery, becomes a vehicle for De Witte's explorations of the abstract patterns provided

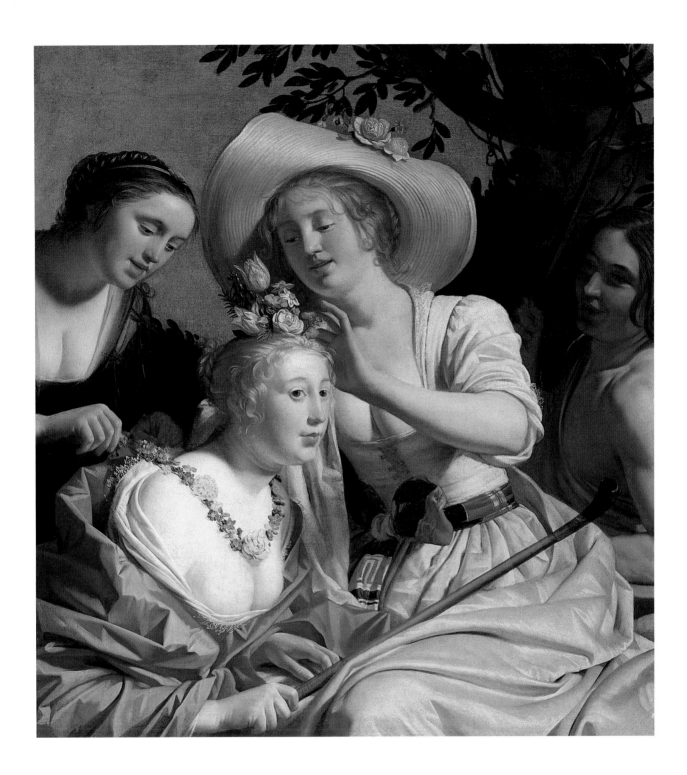

Fig. 41. Gerrit van Honthorst
(Dutch, 1590–1656), *Shepherd-
ess Adorned with Flowers,*
signed on shepherdess's crook
"G v Honthorst fe 1627."
Oil on canvas, 43½ x 39⅞ in.
61.156

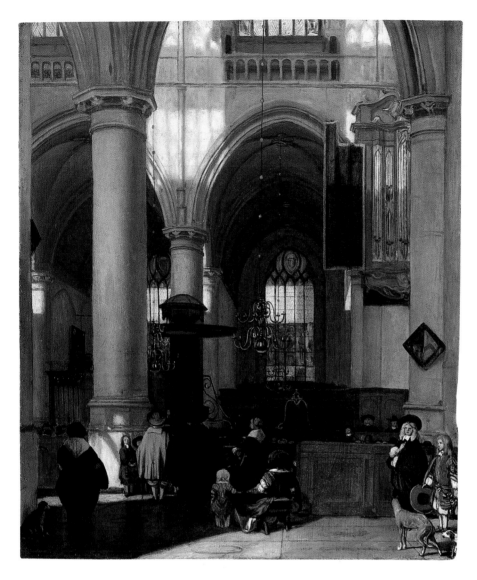

by the setting. Even the church visitors become part of the pattern because of their muted colors and silhouetted shapes.[30]

Modern viewers appreciate the documentary aspect of seventeenth-century Dutch painting, which seems to meticulously record the visible aspects of the everyday world. Yet many of these apparent recordings were in actuality inventions artists created in their studios. That is true of both this quiet church interior and a lavish still life by Abraham van Beyeren (fig. 43). If sober, pleasure-denying Dutch Calvinism was the source of much austere imagery, it could also sustain visual extravagance as long as the underlying message was within the bounds of propriety. The rich display of foods and wares in this painting is a microcosm of the riches enjoyed by seventeenth-century Holland at the height of its dominance of world trade: Chinese export ware, imported fruits, Venetian-style glassware, marvelous Dutch silver,

Fig. 42. Emanuel de Witte (Dutch, c. 1616–1691/92), *Interior of a Protestant Gothic Church,* signed lower left corner "E. DeWitte," c. 1670–74. Oil on oak, 19½ x 16½ in. 61.176

Fig. 43. Abraham van Beyeren
(Dutch, 1620/1–1690), *Banquet
Still Life,* signed at left edge
of table "AVB f," c. 1653–55.
Oil on canvas, 42⅛ x 45½ in.
61.146

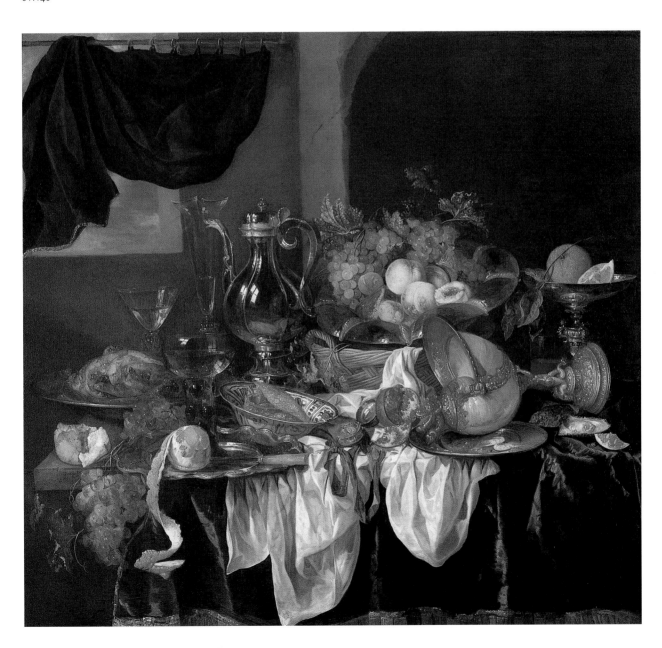

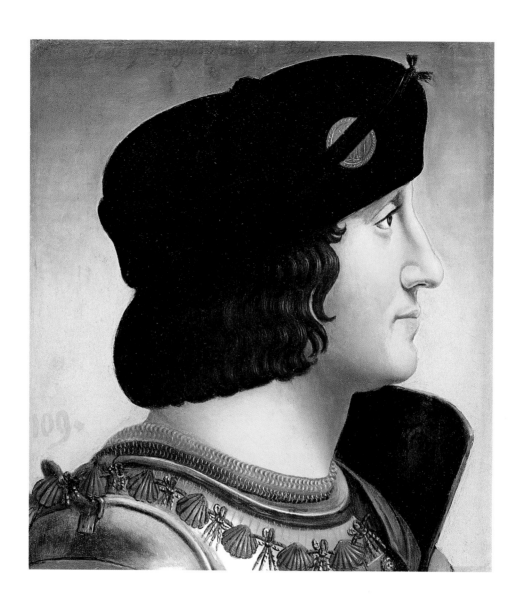

Fig. 44. Bernardino de' Conti
(Milanese, act. 1496–1523),
Charles d'Amboise, c. 1505.
Oil on wood, 13¾ x 12½ in.
61.150

and a prized nautilus-shell cup in a gilt mount all compete for space and attention on a velvet-draped table. The tantalizing array is obviously designed to appeal to more than just the sense of sight; ripe fruits and oysters invite immediate consumption. How could such an overblown, glistening visual feast coexist with the self-denial inherent in traditional Dutch values? Certain clues are embedded in the painting. The over-rich display itself borders on decadence, with fruit teetering between ripeness and rottenness; tipped-over vessels upset the rigorous order prized by the fastidious Dutch; and a small pocket watch next to the grapes is a familiar reminder that time is running out: the viewer would do better to turn thoughts to something more uplifting than earthly appetites. This is a sly painting, though, delivering its message of self-denial by inviting the viewer to first enjoy, and then shun.

PORTRAITURE

In the fourteenth century, almost the only place to find the likeness of a nonroyal person was the depiction of the donor of a devotional work of art—like the earnest, reverent figure gazing up at the monumental Virgin and Child (fig. 12). The usual clues we seek in portraiture—physical features, emblems of vocation, personality—are not evident here. Both artist and donor were dedicated to portraying the essential quality of the donor's Christian piety, far more important in such a work than temporal physical details.

With the growing prosperity, developing sense of history, and greater devotion to earthly life that we can track in the fifteenth century, portraiture became more widespread in major cultural centers such as Bruges, Florence, and Milan. Donor portraits continued to be common, but now individual portraits were also commissioned by members of aristocratic families, government officials, and, increasingly, prosperous businessmen. The uses for official portraiture are not hard to imagine. In an age of politically arranged dynastic marriages, for example, a portrait could be commissioned to show a dignitary the likeness of his prospective bride. An even more common purpose is the visual assertion of power and authority, whether over the family estates or government. Such portraits often follow a set of carefully planned strategies to suggest an imposing physical presence and to confer status.

In the Italian Renaissance, for example, the profile portrait was a vehicle to imply a link with great rulers of the past whose likenesses were struck on medals and coins. Charles d'Amboise, Duc de Chaumont (fig. 44), was governor of Milan under Louis XII from 1500 until his death in 1511. He was also a patron of artists, among them Leonardo da Vinci, and had a particular

interest in coins, so the profile view chosen by the artist, Bernardino de'
Conti, is doubly appropriate. The collar of scallop shells and knots denotes
the Order of Saint Michael, granted to the duke around 1505.[31] The side
view ennobles the sitter but reveals much less individual personality than
the frontal or three-quarter view, which, in Italy, supplanted it in the six-
teenth century.

A painting dated 1572 by the Venetian painter known as Tintoretto
(fig. 45), for example, has as its subject Gabriele Emo, a Venetian official and
governor of the city of Brescia. Wearing the ermine-trimmed velvet robe that
distinguishes him as a procurator of Venice, Emo poses in his official capac-
ity. He is shown in an undistinguished interior that offers no distraction
except a window, which reveals a coast scene beyond—perhaps the Venetian
lagoon—and which may relate to his public identity. His body, its propor-
tions swollen by voluminous garments, is shown three-quarter length and
turned slightly from the viewer. Both these visual devices increase the sense
of bulk and authority, and the stasis of the figure suggests a stability reassur-
ing in a government official. The gestures of his hands suggest openness and
capability, and his head turns to meet the viewer's eyes and gives a sense of
the character of the man beneath the official title.

Though the identity of the sitter has been lost, the frontal stance and
intense gaze give a far stronger sense of individual personality to a portrait
of a man (fig. 46) by Girolamo da Carpi, an artist and architect active in
Ferrara. The massive stone mantel frames the sitter and enforces his impos-
ing physical presence, emphasized also by the voluminous costume. The
gentleman grips the armrest of a chair as though rising to face the viewer.
The portrait seems both timeless and immediate. Girolamo da Carpi spent
his artistic maturity as court painter to the powerful Este family, based in
Ferrara. In their employ from 1536, he was commissioned to paint numerous
paintings, participate in decoration of their villas, and carry out architectural
projects. It is likely that the man in the Kress picture was involved with the
court, but his identity remains unknown.

We know little more about the tentative young woman shown in fig-
ure 47. An inscription above her head gives the initials CAC and the date,
1565. Her brocade dress, gold jewelry, and hair ornaments attest to her eco-
nomic status but do not reveal her identity. She wears two rings and clutches
a prayer book, which may denote this work as a betrothal or marriage por-
trait whose mate has been lost. The expressive but imprecise brushwork
and the somewhat ungainly bulk of the figure remove this portrait from the

Fig. 45. Jacopo Robusti, called
Tintoretto (Venetian, 1518–
1594), *Gabriele di Pietro Emo,
Procurator of San Marco,* signed
"GABRIEL EMO PETRI FIL.
BRIXIE PRAEFEC[TUS] AN 1572."
Oil on canvas, 45⅞ x 35¾ in.
61.171

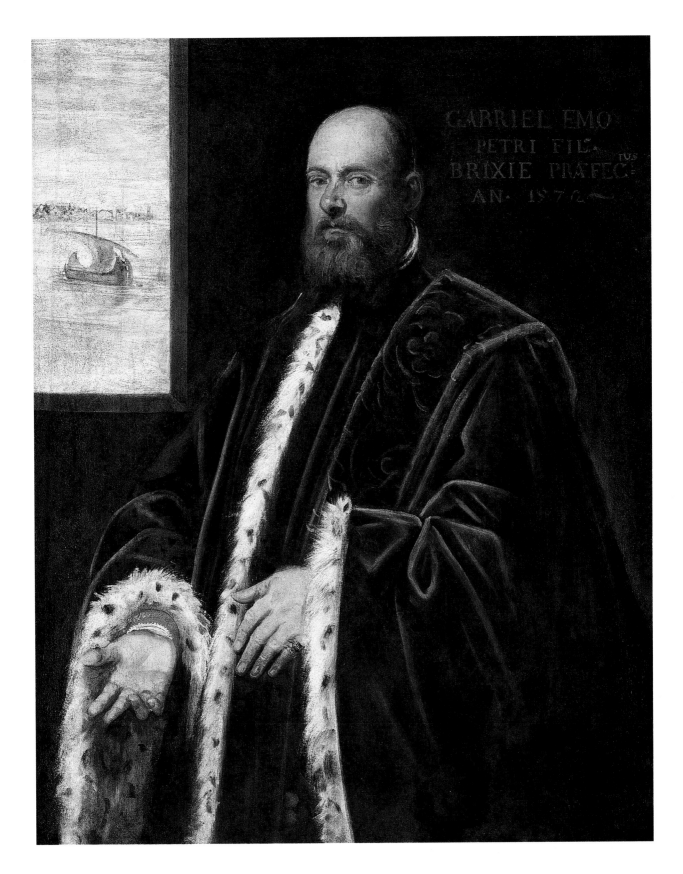

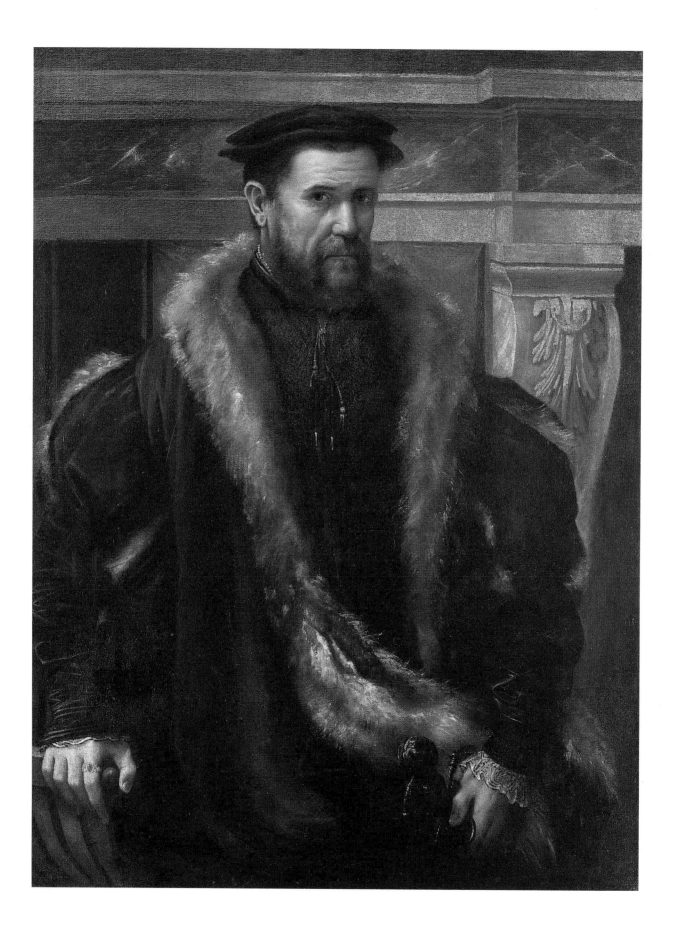

Fig. 46. Girolamo da Carpi
(Ferrarese, 1501–1556),
Man in a Fur Cloak, 1540–43.
Oil on canvas, 43 x 32½ in.
61.164

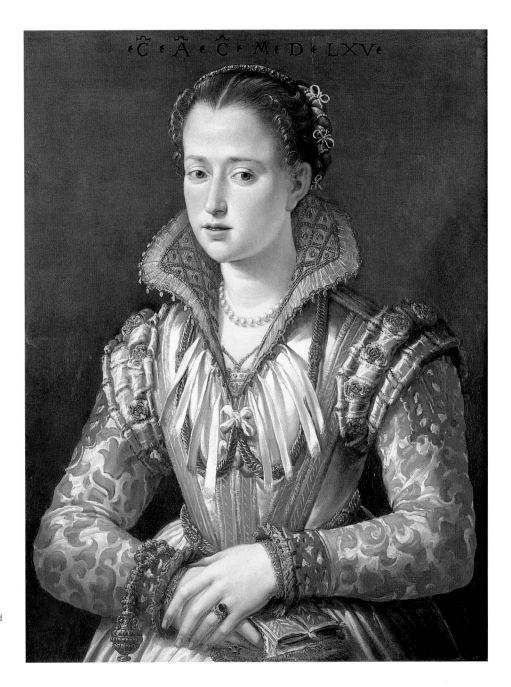

Fig. 47. Unknown Florentine
painter, *Young Woman*, inscribed
at top "C A C m D LXV," 1565.
Oil on wood, 27½ x 21⅜ in.
61.153

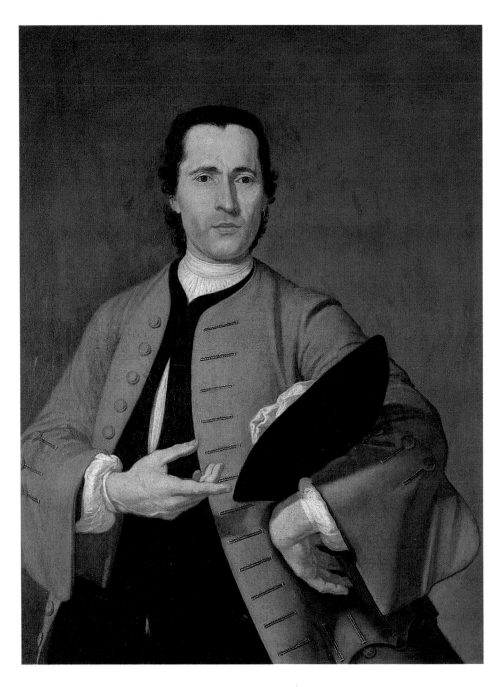

Fig. 48. Giacomo Ceruti
(Brescian, 1691–1761/6),
A Country Gentleman, c. 1750.
Oil on canvas, 37¼ x 29⅜ in.
61.149

refined work of Bronzino or his immediate circle, with whom it has been linked in the past, but no more satisfactory name has so far been proposed.

The young lady is posed against a blank wall, as is the unknown gentleman portrayed by Giacomo Ceruti around 1750 (fig. 48). He occupies a slightly off-center position, and while his hand-on-hip pose and gesturing right hand are meant to impart ease and confidence, his anxious eyes and pursed lips suggest a momentary anxiety not usually seen in painted portraits. That attention to inner psychology, along with the simple composition and flat, almost graphic, treatment of his wonderfully stylized attire, make this portrait appear quite modern.

Here I have tried to supply more of the background information on how and why these works of art were painted than it is possible to convey on a small gallery label. In writing, I hope above all to have raised issues that will enhance the reader's experience of looking at these paintings in their museum setting. I hope it will remind the viewer to look at art with a questioning mind: Was the painting meant to be mounted with other paintings sharing a theme? Was it meant to be seen from below? Have the colors darkened? What would it look like under different lighting? Even though many of these paintings' external clues have been lost through time and circumstance, the artist's essential ability to communicate remains ready for discovery.

NOTES

1. For this reason footnotes will be minimal. Readers are directed to the multivolume catalogue of the Kress Collection for additional information; see Selected Reading List, p. 78.

2. *Stella Maris*, Latin for "star of the sea," is the meaning of Miriam, the Hebrew form of Mary's name.

3. See, for example, the altarpiece by Vivarini in the J. Paul Getty Museum, Malibu, California, illustrated in Burton B. Fredericksen, *Masterpieces of Painting in the J. Paul Getty Museum* (Malibu, Calif.: J. Paul Getty Museum, 1988), p. 5.

4. The sheaves of wheat first appeared in early Netherlandish painting, for example in several altarpieces by the fifteenth-century artist Hugo van der Goes. By the end of the fifteenth century, the influence of northern iconography had become prevalent in Florentine painting.

5. The painting was cleaned in 1995 at the Conservation Center of the Institute of Fine Arts, New York University, New York.

6. The punchwork of the haloes is not original.

7. Dan Ewing discussed the subject in light of Antwerp's sixteenth-century domination of world trade in a talk at Smith College, Northampton, Massachusetts, November 12, 1994.

8. The practice of breaking up altarpieces and removing them from their original setting was conducive to the rise of connoisseurship—sorting out attributions of artists for individual works of art—that dominated art historical practice in the first part of this century.

9. The panel was originally part of an altarpiece of which a *Crucifixion* in the Pinacoteca Nazionale, Bologna, Italy, still survives.

10. For a more detailed discussion of this painting, see Chiyo Ishikawa et al., *A Gift to America: Masterpieces from the Samuel H. Kress Collection* (New York: Abrams, 1994), pp. 116–19.

11. A version, probably earlier, of the *Lamentation* showing only the Virgin, Christ, and angel at the right, is in the Walters Art Gallery, Baltimore. An excellent discussion of the two works is found in Klaus Lankheit, "Two Bronzes by Massimiliano Soldani Benzi," *Journal of the Walters Art Gallery* 19–20 (1956–57): 9–17. The larger group was copied in porcelain by the Doccia factory. Versions exist in the Hispanic Society, New York, the Palazzo Principe Corsini, Florence, and the Konsthistorisk Museum, Stockholm.

12. I am unaware of other related surviving panels.

13. They read "Adscendit Ad Celos Sedet A Dexteram Dei Patris Omnipotentis" (He rose into heaven and sits on the right hand of God the Father Almighty).

14. Saint Catherine was a princess who, during her prayers, experienced a vision that an image of Christ turned to her and placed a ring on her finger. Her "mystic marriage" with Christ was a popular image from the early fourteenth century on.

15. For a proposed reconstruction of the now-dispersed altarpiece see John Pope-Hennessy assisted by Laurence B. Kanter, *The Robert Lehman Collection*, vol. 1, *Italian Paintings* (New York: Princeton University Press in association with the Metropolitan Museum of Art, 1987), pp. 288–89.

16. The altarpiece must have accommodated the different sizes of the Evangelist panels: the Saint Matthew (Museum of Fine Arts, Budapest) and the Saint John (P. de Boer Gallery, Amsterdam) are about eight inches taller than the Saint Mark (Accademia, Siena, Italy) and the Saint Luke. The Evangelist panels were most recently published in Hiltrud Kier and Frank Günter Zehnder, eds., *Lust und Verlust: Kölner Sammler zwischen Trikolore und Preussenadler* (Cologne: Wienand, 1995), pp. 587–88; and H. W. van Os et al., eds., *The Early Sienese Paintings in Holland* (The Hague: G. Schwarz/SDU, 1989), pp. 81–83.

17. Two panels from this series are in the Pinacoteca, Siena, Italy, and one is in the Christian Museum, Esztergom, Hungary.

18. An unfinished painting by Fra Bartolommeo, of nearly identical dimensions and showing only the background scene of the first family, is now in the Johnson Collection, Philadelphia Museum of Art. It was the source for a painting by Bacchiaca (formerly Potsdam, lost in World War II), and also a painting by Fra Paolino (Museo Clemente Rospigliosi, Pistoia, Italy), which shows the

creation of Eve in the background. Another version of the Seattle composition was at one time in a Swedish private collection, but its present whereabouts are unknown.

19. Cristelle L. Baskins, in correspondence of December 30, 1996 (on file at Seattle Art Museum). Her findings will be published in *Adversity's Daughters: Exemplary Histories in Tuscan Cassone Painting* (Cambridge: Cambridge University Press, forthcoming).

20. Everett Fahy, in correspondence dated March 20, 1994 (on file at Seattle Art Museum), is the most recent scholar to endorse the attribution to Uccello. Cristelle Baskins attributes the painting to the Master of Marradi; see n. 19.

21. Kress conservator Mario Modestini, who worked on the painting in 1952 and 1954, is convinced that despite its problems of condition the work is autograph (note on file at Seattle Art Museum). In a letter dated May 12, 1988 (on file at Seattle Art Museum), Beverly Louise Brown noted that she and Sidney Freedberg of the National Gallery of Art believed that the painting was produced in Paolo Veronese's shop by his son Benedetto.

22. Beverly Louise Brown, *Giambattista Tiepolo: Master of the Oil Sketch* (Milan and Fort Worth: Electa and Kimbell Art Museum, 1993), pp. 279–80, convincingly identifies the subject, which had previously been called *Glorification of a Member of the Porto Family*.

23. The Kress Foundation purchased both paintings for Seattle from the Paul Drey Collection.

24. In 1954 a staff member of the Seattle Art Museum, Edward Thomas, visited the Porto palace and saw retouched traces of the Tiepolo ceiling in its original location. Niches showing the location of the monochrome paintings were still present (notes on file at Seattle Art Museum).

25. George Knox, "Tiepolo Paintings at Birmingham [Alabama]," *Burlington Magazine* 120 (1978): 189, and *Giambattista and Domenico Tiepolo: A Study and Catalogue Raisonné of the Chalk Drawings* (Oxford and New York: Oxford University Press, 1980), vol. 1, p. 323, suggests that Domenico was the author of both fresco and sketch.

26. The uncharacteristic imprecision in this painting led Kress conservator Mario Modestini to attribute it to the later English follower of Canaletto, William James, active in the second half of the eighteenth century (note on file at Seattle Art Museum).

27. See W. G. Constable, *Canaletto: Giovanni Antonio Canal 1697–1768*, 2nd ed., revised by J. G. Links (Oxford: Oxford University Press, 1976), vol. 2, pp. 246–47 for a list.

28. For further information on this painting, see Ishikawa et al., op. cit., pp. 160–63.

29. The 1632 inventory of his living quarters records a painting "with shepherdesses by Honthorst." See ibid., pp. 155–59 for further discussion.

30. See ibid., pp. 181–84 for further information.

31. Patricia Trutty-Coohill, *Studies in the School of Leonardo da Vinci: Paintings in Public Collections in the United States with a Chronology of the Activity of Leonardo and His Pupils and Catalogue of Auction Sales* (Ann Arbor: University Microfilms International, 1982), p. 257.

Selected Reading

Aston, Margaret. *Panorama of the Renaissance*. New York: Harry N. Abrams, 1996.

Balis, Arnout, Carl van de Velde, and Hans Vlieghe, eds. *Flemish Paintings in America: A Survey of Early Netherlandish and Flemish Paintings in the Public Collections of North America*. Translated by Ted Alkins and Linda van Thielen. Antwerp: Fonds Mercator, 1992.

Bomford, David, et al. *Italian Painting before 1400*. Art in the Making. New Haven, Conn., and London: Yale University Press in association with National Gallery Publications, 1989.

Brown, Christopher. *Images of a Golden Past: Dutch Genre Painting of the 17th Century*. New York: Abbeville Press Publishers, 1984.

Brown, Jonathan. *Kings and Connoisseurs: Collecting Art in Seventeenth-Century Europe*. Princeton: Princeton University Press, 1995.

Caroselli, Susan L. *Italian Panel Painting of the Early Renaissance in the Collection of the Los Angeles County Museum of Art*. Los Angeles: Los Angeles County Museum of Art in association with University of Washington Press, 1994.

Carr, Dawson W., and Mark Leonard. *Looking at Paintings: A Guide to Technical Terms*. Malibu, Calif.: J. Paul Getty Museum in association with British Museum Press, 1992.

Dunkerton, Jill, Susan Foister, Dillian Gordon, and Nicholas Penny. *Giotto to Dürer: Early Renaissance Painting in the National Gallery*. New Haven, Conn., and London: Yale University Press in association with National Gallery Publications Limited, 1991.

Eisler, Colin. *Complete Catalogue of the Samuel H. Kress Collection: European Paintings Excluding Italian*. London: Phaidon Press for the Samuel H. Kress Foundation, 1977.

Elliott, Sara. *Italian Renaissance Painting*. London: Phaidon Colour Library, 1993.

Haak, Bob. *The Golden Age: Dutch Painters of the Seventeenth Century*. Translated and edited by Elizabeth Willems-Treeman. New York: Stewart, Tabori and Chang with the cooperation of the Prince Bernhard Foundation, 1996.

Hartt, Frederick. *History of Italian Renaissance Art: Painting, Sculpture, Architecture*. Third edition. New York: Harry N. Abrams, 1987.

Keyes, George, István Barkóczi, and Jane Satkowski, eds. *Treasures of Venice: Paintings from the Museum of Fine Arts Budapest*. Minneapolis: Minneapolis Institute of Arts, 1995.

Martineau, Jane, and Andrew Robison, eds. *The Glory of Venice*. New Haven, Conn., and London: Yale University Press, 1994.

Paoletti, John T., and Gary M. Radke. *Art in Renaissance Italy*. New York: Harry N. Abrams, 1997.

Shapley, Fern Rusk. *Paintings from the Samuel H. Kress Collection: Italian Schools XV–XVI Century*. 3 vols. London: Phaidon Press for the Samuel H. Kress Foundation, 1968.